KENILWORTH
THROUGH TIME
Jacqueline Cameron

AMBERLEY PUBLISHING

Dedicated to Helen whose help in finding postcards
for the book is appreciated very much.

First published 2010

Amberley Publishing Plc
Cirencester Road, Chalford,
Stroud, Gloucestershire, GL6 8PE

www.amberley-books.com

Copyright © Jacqueline Cameron, 2010

The right of Jacqueline Cameron to be identified
as the Author of this work has been asserted in
accordance with the Copyrights, Designs and
Patents Act 1988.

ISBN 978 1 84868 999 2

British Library Cataloguing in Publication Data.
A catalogue record for this book is available from
the British Library.

Typeset in 9.5pt on 12pt Celeste.
Typesetting by Amberley Publishing.
Printed in the UK.

Introduction

When I was asked by Alan Sutton to write *Kenilworth Through Time*, I thought, Kenilworth! This was the town where anyone living around the area travelled through *en route* to Warwick or Leamington Spa or in the other direction Coventry.

The first thing to hit you is the steep history that envelopes the town, its castle, memorial, the abbey ruins and the Abbey Fields to mention a few of the town's historic assets. Along with this is the water tower, one of those lovely old buildings which have now been converted into a private residence, one which you would like to live in when you pass it. Originally built as a windmill in 1778, it was later converted to steam power in 1854. It was to be thirty years after this date that the milling machinery was removed and from then until the early 1960s the mill, which had been converted, acted as a water tower. At this time the building ceased to be the main water supply to Kenilworth and it became derelict. Thanks to the ingenious plans of the architect the mill has now been converted into a most unusual residence which stands on Tainters Hill.

To appreciate Kenilworth you only have to look down the main street and you can see a mixture of old and new buildings, with a number of these being post-war.

A delightful clock tower stands in the centre of the town and looks down the main Warwick Road. The clock tower was presented to the town of Kenilworth by G. W. Turner in 1906, rather touchingly in memory of his wife. Like all Midland towns Kenilworth was no exception to the German assault and in 1940 the upper part of the clock was damaged when a landmine was dropped nearby causing considerable damage. There were also a number of casualties resulting from this act. It wasn't until 1973 that the clock tower was restored thanks to the generosity of Kenilworth Urban District Council.

It is difficult to imagine that Kenilworth has some 135 buildings which are considered of architectural and historic interest. One of

these is the Old School House which is a handsome example of the town's history. Consisting of two storeys the brick and tile building which stands on a sandstone plinth, originally had two front rooms on the ground floor, with a central passage to what was probably the school itself at the rear of the building. After the school closed it was converted into two cottages in 1882. Built in 1724 as a free school for the children of the parish, this was thanks to the generosity of Dr William Edwards, the benefactor, who was a surgeon and bonesetter. He passed away in 1723. In fact Dr Edwards was quite a man as he also endowed the education of boys in Hatton. His wealth appears to have come from successful business ventures in timber dealing, estate investments and a partnership in an oil mill at Guy's Cliffe! Since 1906 when the charity sold the school it was converted into a single residence.

No account of Kenilworth would be complete without mention of the old town which was originally centred on Bridge Street and High Street just north of the Abbey Fields.

In the area can be found a number of listed buildings, for example parts of the Clarendon House Hotel date back to 1538 and it still contains some fine examples of the original four poster beds. If it is public houses you are interested in the Virgin and Castle offers a step back in time as it is full of historic atmosphere.

Little Virginia originally consisting of fifteen cottages thought to be the homes of masons and builders employed by the sixteenth century Robert Dudley, Earl of Leicester. The cottages were declared derelict in 1973 and were dutifully restored into a magnificent hamlet. An excavation that was carried out at this time by the local history society found a stone medallion in the wall bearing the monogram R, which suggests the houses were more likely to be seventeenth century.

Lying in the heart of the Midlands, Kenilworth's history goes back to the Domesday survey of 1086 and there is evidence of a previous occupation. With a population of around 25,000 people the main part of the town was to the south of Abbey Fields. Once the site of an Augustinian Priory some of the ruins can still be seen on the Abbey Fields to this day. I was quite impressed to find Abbey Fields a delightful place to walk through.

The famous Kenilworth Ford is fed by Finham Brook which runs through the Abbey Fields and in heavy rain is the main culprit in local flooding.

There are a number of timber framed cottages dating back to the sixteenth century found in this area.

Not short of places of interest Crackley Woods and Kenilworth Common are great places to visit.

The Parish Church of St. Nicholas overlooks the abbey field and it is said that Queen Elizabeth I took communion there. The fish house, known locally as the barn, and the gateway can also be found here. The spire of the church was struck by lightening twice in one evening and had to be rebuilt. The font dates back to 1664 but the base is Norman. The elaborate Norman doorway at the west entrance originally came from the abbey.

The reddish brown sandstone of the Kenilworth Castle ruins stand stark against the skyline and was founded about 1120 when Geoffrey de Clinton, Chamberlain and Treasurer to Henry I, was granted land by the King for the castle and abbey. The great hall and private apartments were built in the fourteenth century. The gatehouse and stables (or barn) were the last two additions to the castle and were the only buildings to survive virtually undamaged after the Civil War when in 1649 Parliament declared that the castle be made untenable. By the latter part of the twelfth century a massive Norman keep was completed and in the early thirteenth century a dam was constructed creating a large defensive mere which stretched $1\frac{1}{2}$ to 2 km to the west and south. In 1937 the castle was purchased by Sir John Siddeley, later the first Baron Kenilworth. In 1958 his son presented the castle to the people of Kenilworth and it is now owned by the Kenilworth Town Council and is under the guardianship of English Heritage. It has to be said that the person to put the castle on the map by raising public interest in 1821 was Sir Walter Scott, who wrote the novel *Kenilworth*, which he based on Elizabethan times at the castle.

Kenilworth has a lively and friendly character which offers a combination of historic, residential and leisure amenities.

I have to admit that apart from going to the open air swimming pool when I was a young girl, watching the occasional play at the Priory Theatre and passing through the town from A to B, I had not given the town of Kenilworth a lot of thought but thanks to Alan Sutton and his *Through Time* Series I have discovered a very interesting corner of the world.

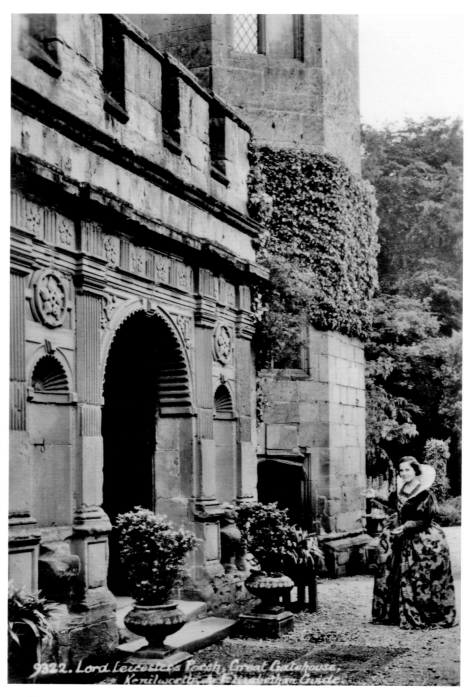

Lord Leicester's Porch, Great Gatehouse, Kenilworth and Elizabethan Guide.

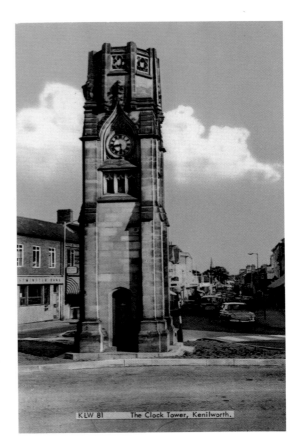

KLW 81 The Clock Tower, Kenilworth.

The Clock Tower

Standing in the square and surrounded by three steps, which have now been buried below the raised street level, the clock tower was dedicated to the town in 1906. Presented to Kenilworth by G. W. Turner as a memorial to his wife it has stood the test of time and forms a centrepiece as you travel up the main street in the town.

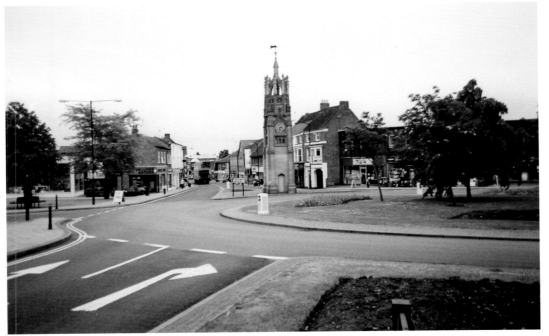

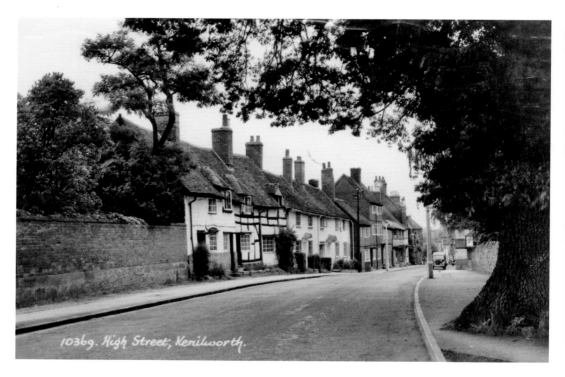

10369. High Street, Kenilworth.

The High Street
Situated in the old part of town, the High Street skirts the Abbey Fields and leads down past Little Virginia to the castle.

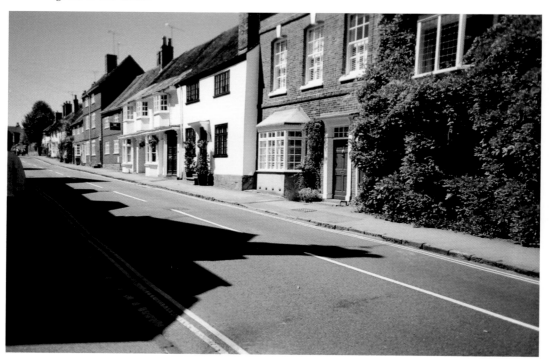

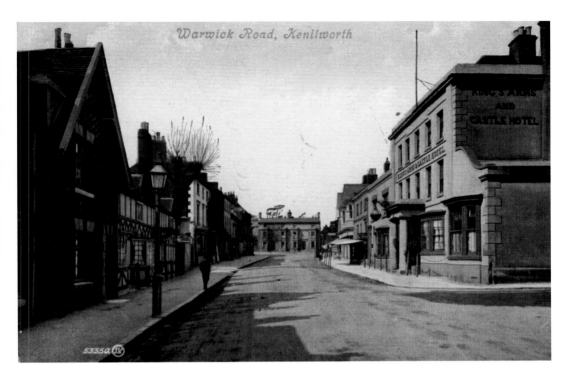

Warwick Road, Kenilworth

The Changing Face of Kenilworth

The building on the right was the Kings Arms and Castle, and was reputed to be the place where Sir Walter Scott penned his novel *Kenilworth*. Times have changed and having been recently modernised and the place has taken on a new look as a bistro and bar.

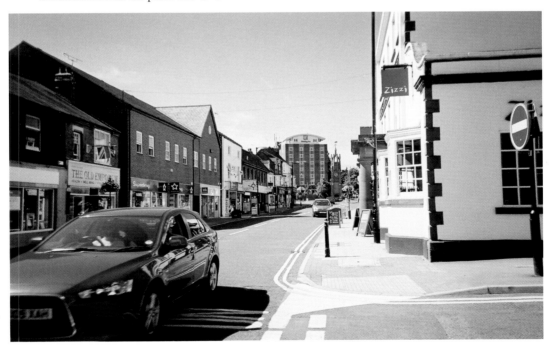

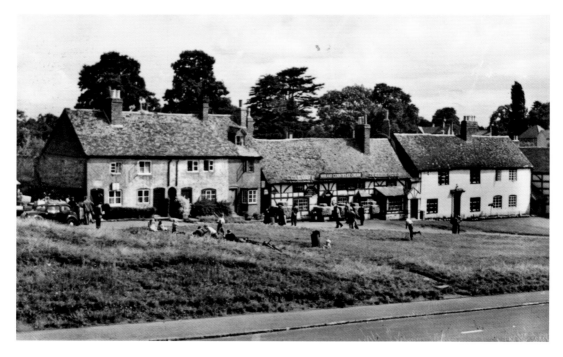

Café and Tearooms

A lovely view of the Castle Green where in times past there would have been cafés and tearooms open for business. Tables and chairs were placed on the grass so that visitors could admire the castle while they took their refreshments.

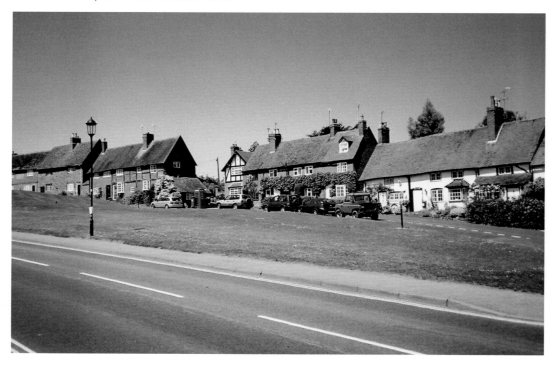

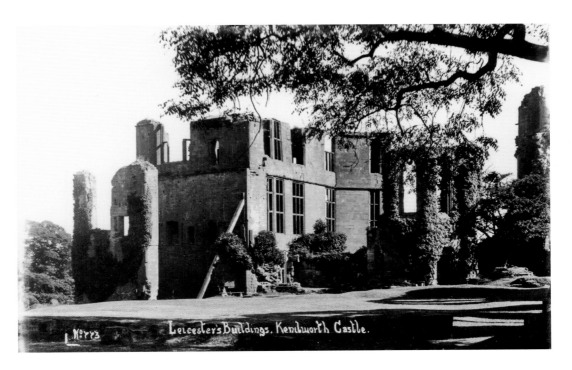

Leicester's Buildings, Kenilworth Castle.

Leicester Buildings

Here are two more contrasting views of the castle through time which is very popular with tourists. No mention of the castle would be complete without reference to the novel *Kenilworth* written by Sir Walter Scott and published in 1821 which is set in Elizabethan times at the castle. The bottom photograph shows new additions to the knot garden.

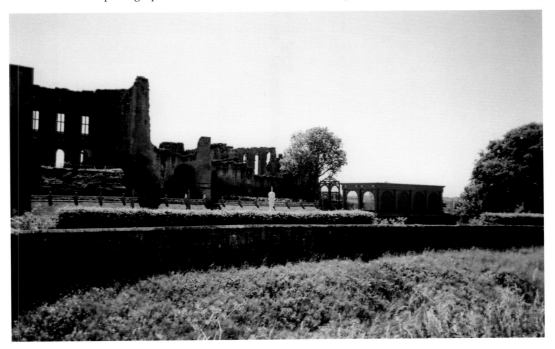

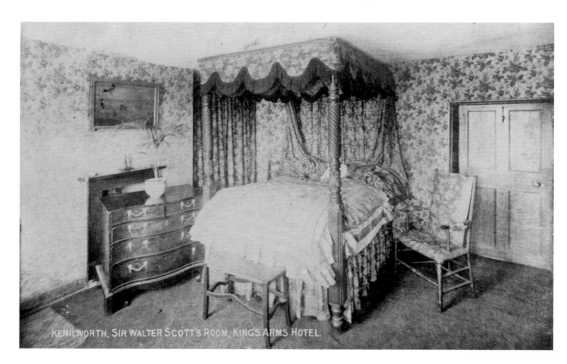

KENILWORTH, SIR WALTER SCOTT'S ROOM, KING'S ARMS HOTEL.

The Kings Arms and Castle Hotel

The lovely postcard of Sir Walter Scott's bedroom in the Kings Arms and Castle was typical of the celebrated guest who frequented the hotel in its heyday. It was here that Sir Walter Scott wrote his novel *Kenilworth*. His bedroom was preserved until the 1960s.

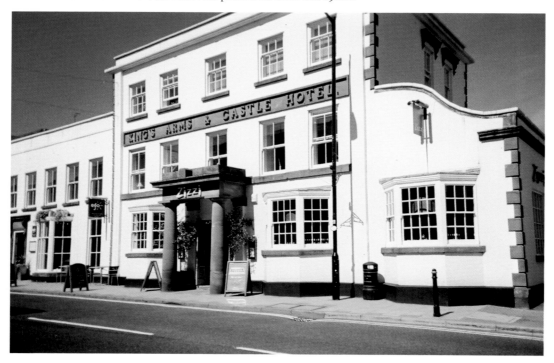

The Bank Gallery

Old Kenilworth originally centred on Bridge Street and the High Street. You access this area just north of the Abbey Fields. Fine listed buildings can be found here, all beautifully maintained and dating back to 1538. When I last visited this corner of Kenilworth there was the bank gallery, a collection of craft and gift shops, a delightful café and the Jane Powell Art Studio in the basement. Alas, all this is no more and the locked gate is a sad reminder of the changing times.

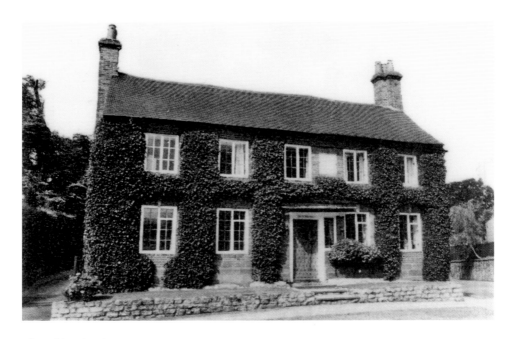

The Old School House

Standing in Barrowell Lane, the old school house is one of some 135 buildings in the town being of architectural interest. Built in 1724 as a free school for the children of the parish, the benefactor was Dr. William Edwards, who died in 1723 after a career as a surgeon and bonesetter. He also had successful business interests, a partnership in an oil mill at Guy's Cliffe, estate investments and timber dealings which enabled him to be such a generous individual. The school was a two-storey brick and tile building which stood on a sandstone plinth. As you pass the police station and head towards the castle it is the impressive building in front of you. Since 1906 the house has been converted into a private residence.

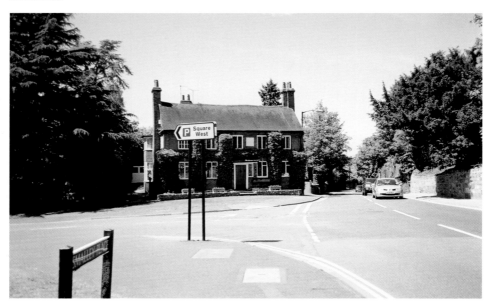

Sundial

Partly incorporated in the surviving ruins of an Augustinian Priors which was founded in 1122 by Geoffrey de Clinton, Chamberlain of Henry I, the Parish Church of St Nicholas lays claim to one of the finest Norman doorways in Warwickshire. If you walk past this doorway and continue down through the trees, midway between the third and fourth tree you will find a pre 1700 sundial. Repairs have been carried out to the sundial since its erection, which was probably before the trees were planted. Despite its age the sundial is a fine example of the period.

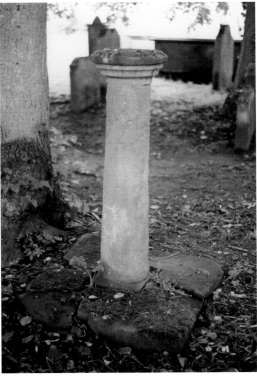

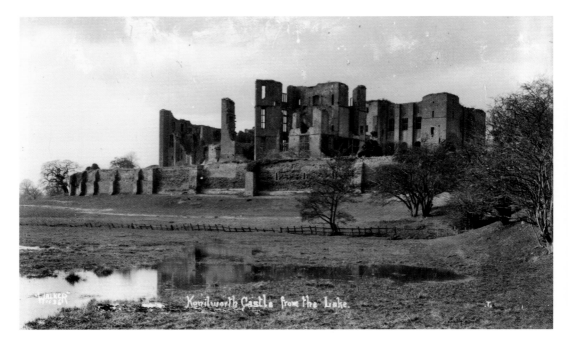

Kenilworth Castle from the Lake.

Kenilworth Castle

When Geoffrey de Clinton, Chamberlain and Treasurer to Henry I was granted lands by the king in about 1120 he founded Kenilworth Castle and Abbey. Occupied initially by a motte and bailey, things were to change during the latter part of the twelfth century when the massive Norman keep was completed. During much of its life the castle was held by the crown. It was also granted to some of the more interesting personalities two such names were Simon de Montfort and John of Gaunt, the Duke of Lancaster. These two lovely views of the castle show that little has changed through time.

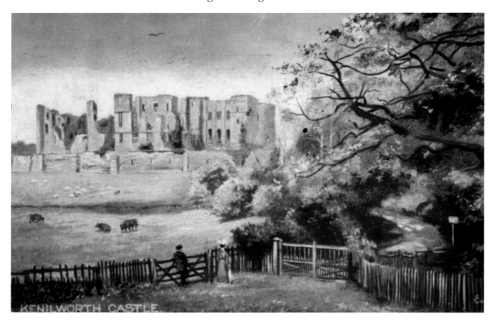

KENILWORTH CASTLE.

A Bit of Old Kenilworth
With the castle in the background, these houses would be passed as you walk down to the Castle Green. On the left at the bottom of the hill would be Little Virginia.

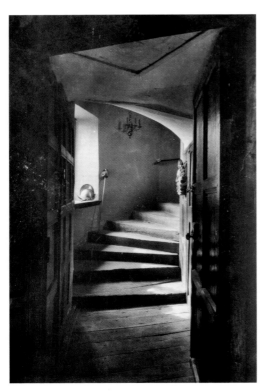

Inside Looking Out

Two more views of the castle, this time from inside the building. The top picture is of the turret stairway in the great gatehouse. The bottom photograph is of the Kenilworth Town Council Chamber in the castle gatehouse.

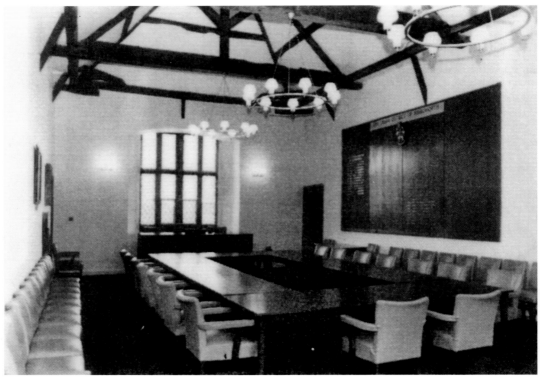

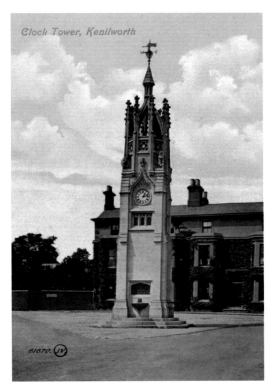

Clock Tower

Taken before the days of Glasspool the chemist's and Beatrice hair salon, this lovely old postcard of the clock tower gives us an insight into the area before the arrival of the de Montfort Hotel. It is currently trading as the Holiday Inn.

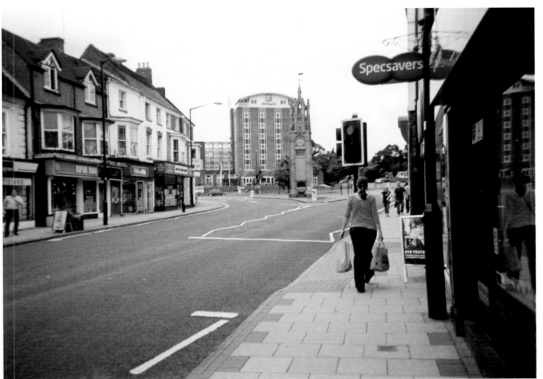

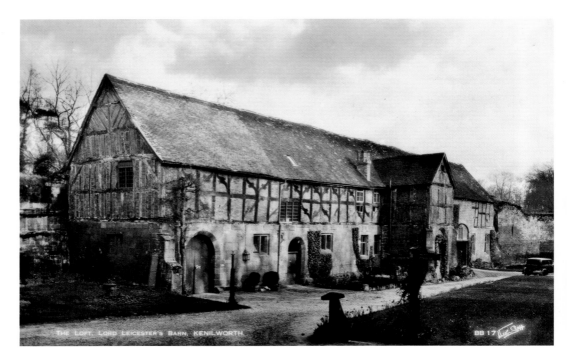

The Loft, Lord Leicester's Barn

This lovely old building at the top of the page and the picture on the bottom of the page have nothing in common, but having said this, I suppose they do, as one belonged to the Castle and the other the Abbey. I just felt they should be included in the book.

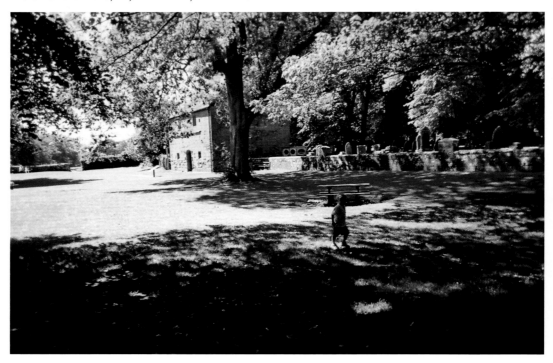

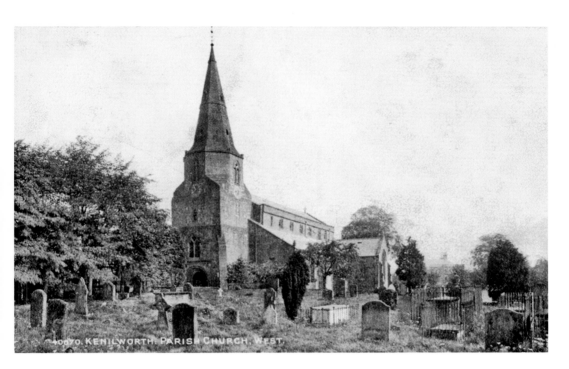

St Nicholas Church

Situated in the northern part of Kenilworth, and standing adjacent to the oldest part of town, the High Street, is the church of St Nicholas. The font is dated 1664 but the base is Norman. At the chancel steps stands a pig of lead, which was a piece of roof taken from the monastery at the dissolution and melted down. This unusual item weighing nearly 11 hundred weight bears the stamp of the commissioner of Henry VIII.

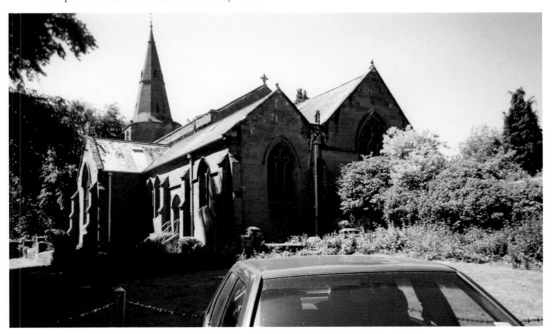

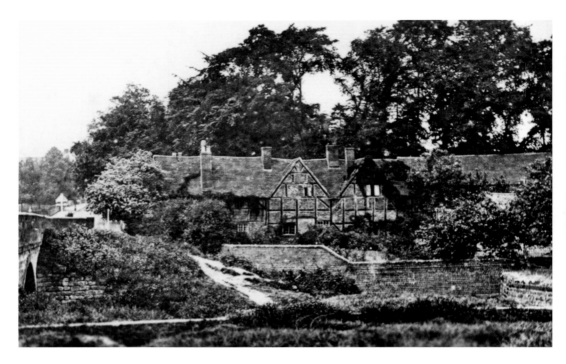

A Peep into the Past

I love these two lovely old postcards showing the beauty of the cottages in Kenilworth in times past. They have an aura of peace and tranquillity about them.

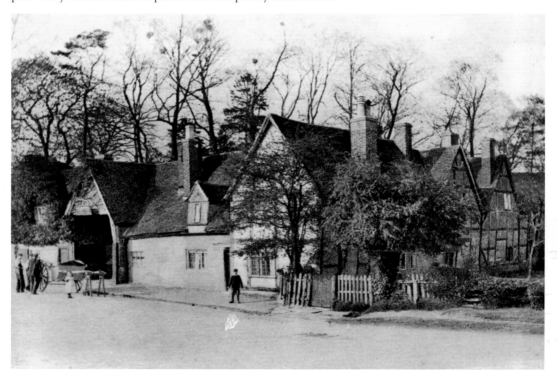

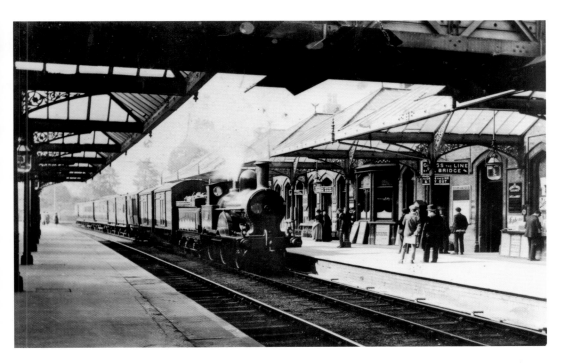

Kenilworth Railway Station
This beautiful old postcard taken around 1913 shows a 6' 6" Newton Class locomotive in Kenilworth Station. Standing in Farmer Ward Road the railway gave easy access to the cinema which was on the opposite side of the road. The railway closed in 1969 with the demolition of the station commencing in February. The London and Birmingham Railway was built on the Kenilworth side of Coventry in the latter half of the 1830s.

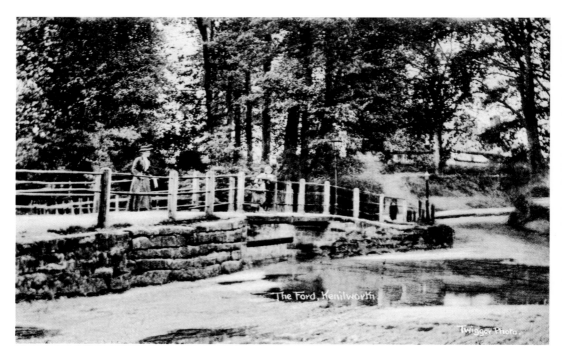

Kenilworth Ford

Here we see two lovely old postcard views of the ford in the days when traffic was light and a walk over the ford would have been a pleasure. Although many years have passed since these pictures were taken the ford still floods heavily to this day when excessive rain is around.

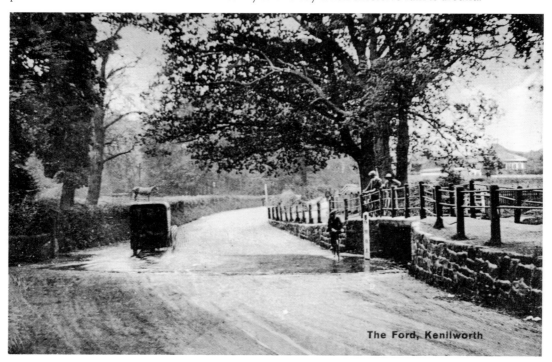

The Ford, Kenilworth

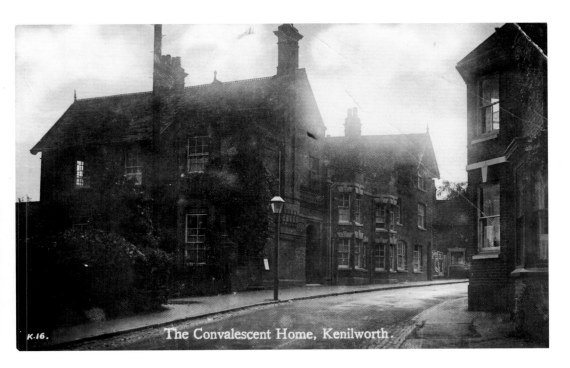

The Convalescent Home, Kenilworth.

Convalescent Home

The home was founded in 1878 and stood in the High Street. Mainly supported by voluntary contributions it had thirty-one beds which provided general accommodation for those requiring convalescence, so anyone with incurable diseases, mental illness or infectious illness were not nursed here.

Margaret Hills SRN

No history of Kenilworth would be complete without reference to the marvellous work of the late Margaret Hills and the great service she has given to sufferers of arthritis all over the country. With a clinic and a shop in Kenilworth, Margaret who passed away in May 2003, was joined by her daughter Christine and following in grandmother's footsteps, Christine's daughter Julia, who herself had been diagnosed with juvenile arthritis at the age of eight, joined the company in January 2006, after intensive training. Since joining the clinic Julia has qualified as a practitioner of Inter X/Scenar technology for the treatment of pain. Now they have an information centre in the town and the ladies in the bottom photograph from left to right are Rosie Dyke, Angie Rossborough and Anne Wallace who run the shop for her. As someone who has suffered for many years with arthritis and been a patient for longer than I care to think about I can vouch her treatment works.

In the top picture left to right is Margaret Hills SRN, Christine Horner ECNP MRNT and Julia Horner BSC MRNT.

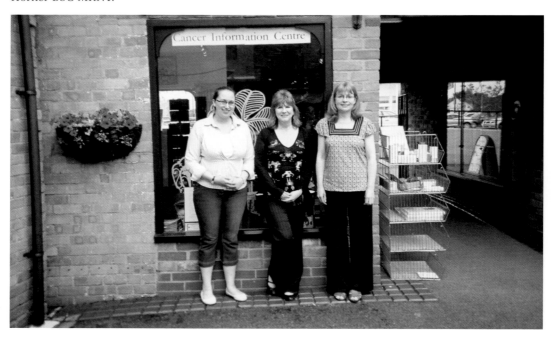

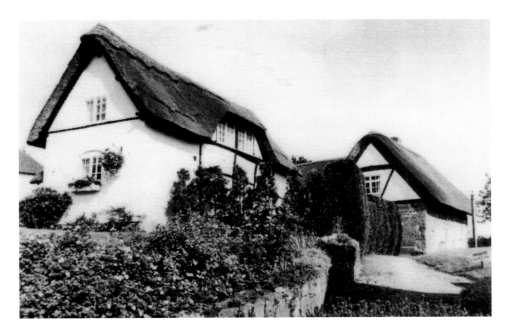

Little Virginia

Just along the road from the castle lies the hamlet of Little Virginia. The subjects of an expensive restoration project the fifteen cottages, which had originally been declared derelict in 1973, were restored to a magnificent hamlet of period cottages. It was widely believed that Little Virginia was made up of the homes of masons and builders employed by the sixteenth-century Robert Dudley, Earl of Leicester. However, an excavation carried out in 1973 by the History Society suggested the cottages were more likely to have been built in the seventeenth century.

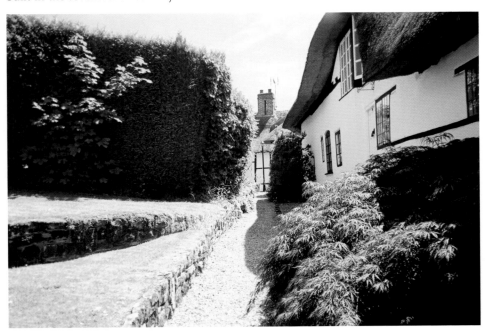

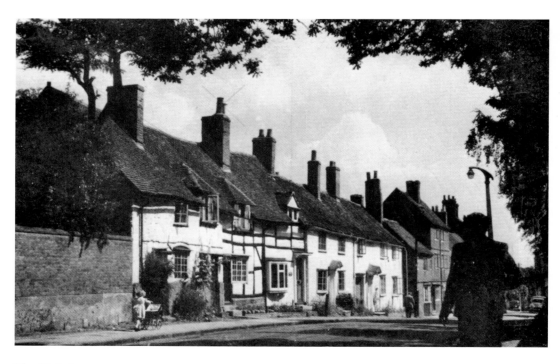

The High Street

The oldest part of the town of Kenilworth is the High Street and here we see how little it has changed over the years.

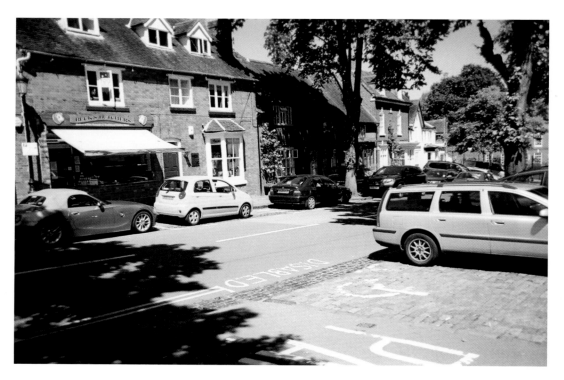

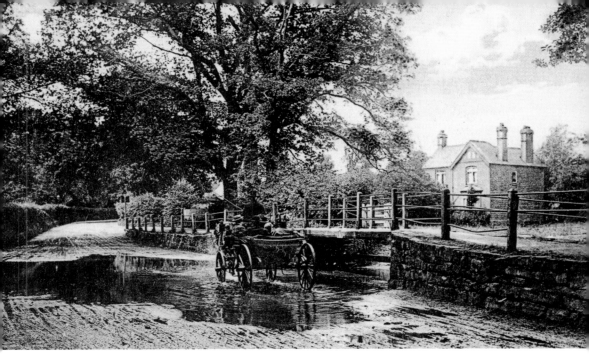

The Ford

Here we see two contrasting views of the Ford taken on old postcards. I love these old postcards and include them whenever I can. They just have a natural beauty.

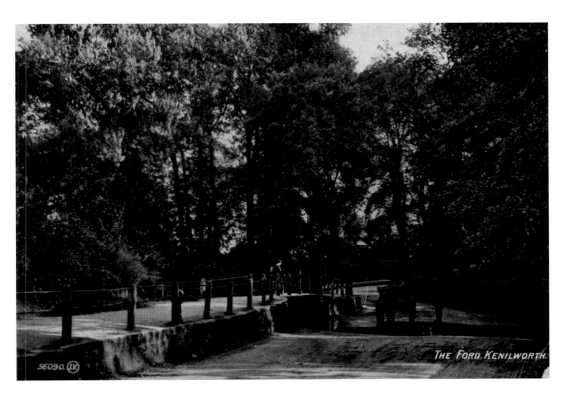

THE FORD. KENILWORTH.

56090. (JV)

Kenilworth. (from the Castle.)

Castle Green

As you approach Kenilworth from the north of the town you pass the castle on your right and the famous Castle Green on your left. In times past this was the meeting point to mark special events in the town such as coronations, battles successfully won and jubilees. Guy Fawkes Night was another occasion for celebration on the Green when a huge bonfire could be seen on the mound between the road and the castle wall. However, with the increased traffic in the fifties this ceased in the interest of safety and even the lighting of a beacon is forbidden today.

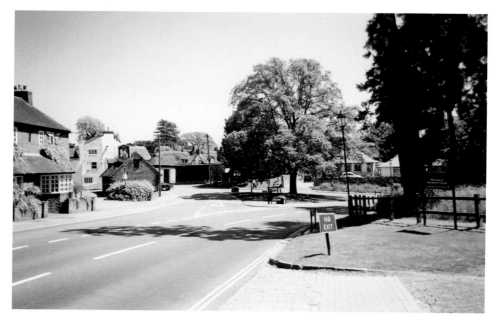

The Abbey Fields

These are no ordinary fields, in fact Abbey Fields are considered to be the town's most attractive feature. Consisting of 68 acres of rolling fields, which can be found in the centre of Kenilworth, the land was donated by benefactors from 1884 onwards. They are a pleasure to visit and form a magnificent approach to the castle, St Nicholas Church and the remains of the abbey.

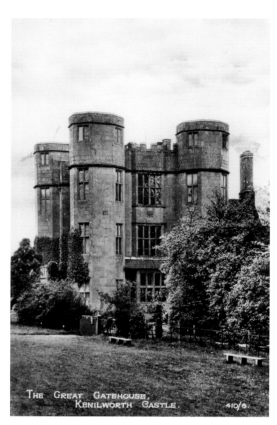

THE GREAT GATEHOUSE,
KENILWORTH CASTLE. 410/6.

The Castle
Founded about 1120 the Great Hall and private apartments were built in the fourteenth century. Situated on the western edge of the town, Kenilworth Castle is an imposing sight no matter how you approach it.

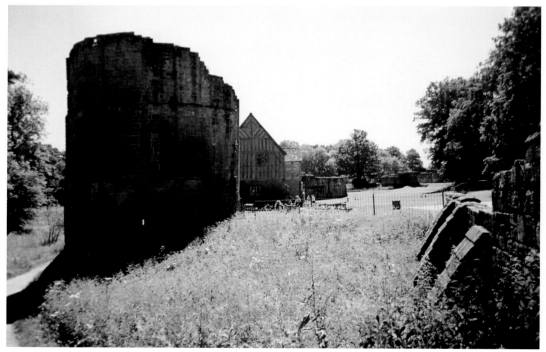

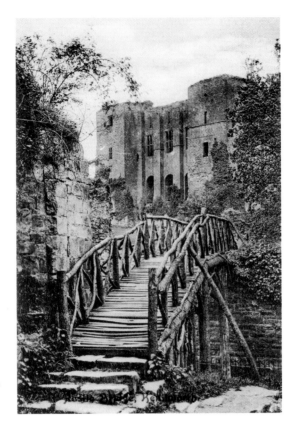

Rustic Bridge
The famous Rustic Bridge at Kenilworth Castle that once allowed access to part of the Tiltyard, this area is prone to flooding and on 29 July 1834 a torrential rainstorm lasting for some five hours brought about the demise of an adjacent bridge.

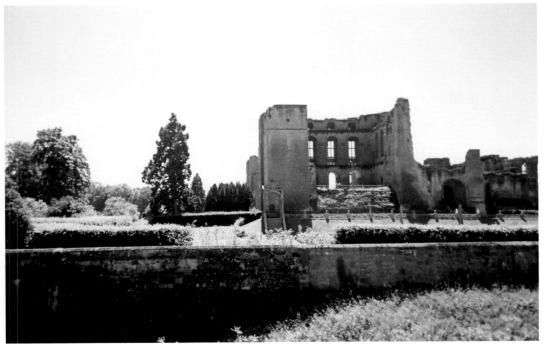

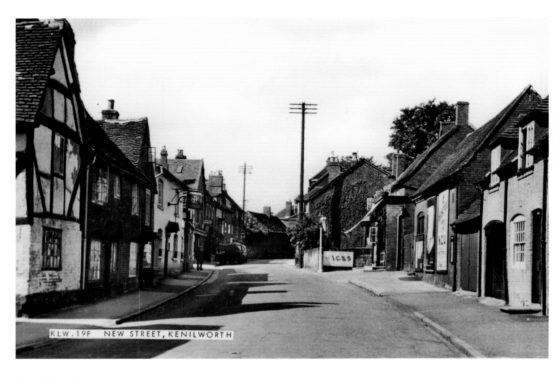

KLW.19F NEW STREET, KENILWORTH

New Street

I was very lucky to capture the bottom photograph with very little traffic as this is usually a very busy road. I believe England was playing in the World Cup at the time I took the photograph.

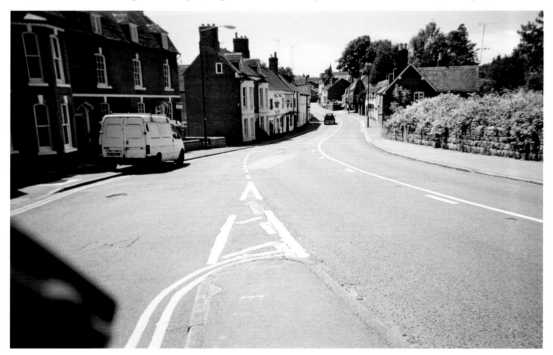

Abbotsford School
Standing in Bridge Street in the old part of town the school looks after the needs of junior boys and girls 3–11 years old and at the time the top photograph was taken senior girls 11–16 years old. An independent school which has been established in the town for many years celebrates its hundredth birthday this year.

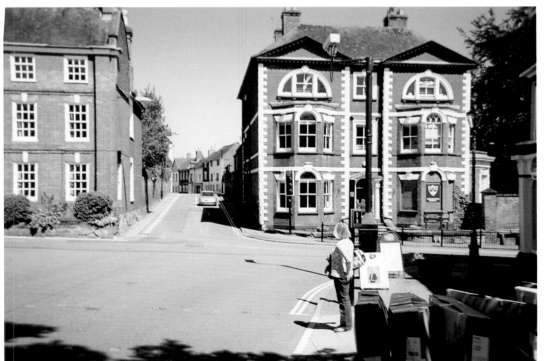

Abbotsford School

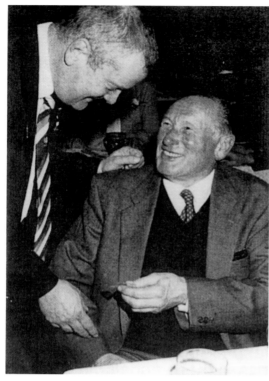

Paul Chase

Kenilworth man Paul Chase travelled for many years from Kenilworth to the Ford Motor Company in Royal Leamington Spa to work. After retirement he liked nothing better than to enjoy the yearly Pensioner's Christmas Reunion Party held at the Spa Centre to catch up on all the news. The chap talking to Paul on the left is his old work mate Roger Chapman.

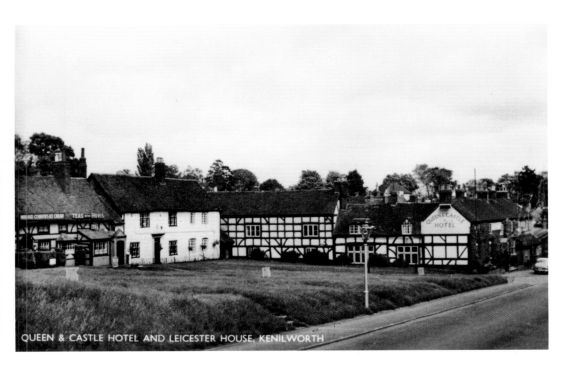

QUEEN & CASTLE HOTEL AND LEICESTER HOUSE, KENILWORTH

Queen and Castle

The cottages on the green are believed to have housed the staff who provided essential services for the castle. During the early twentieth century the cottages were badly neglected and it wasn't until 1974 that the renovation work was completed. In the picture we see Leicester House and the famous Queen and Castle public house which adjoins the green. To the left of the top picture you can see the Cosy Café. I have included these photographs together so that the reader gets a good impression of how large the green is.

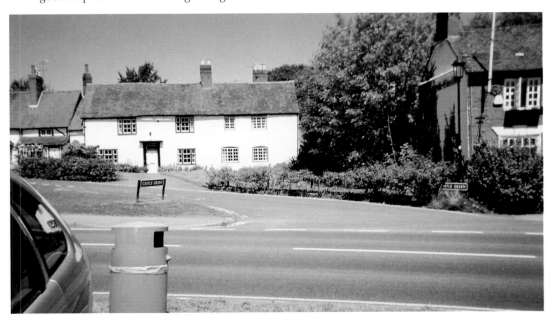

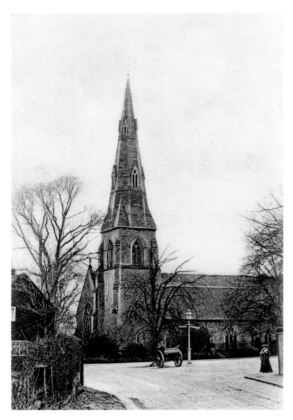

St John

The Parish Church of St John the Evangelist which stands just off the roundabout in Warwick Road, cost over £3,000 to build and was constructed in 1852 when Kenilworth was divided into two parishes. The money for the church was raised by subscription. On the opposite side of the road to the church Hughes the baker, Percy Fox the butcher and the Malt Shovel public house conducted their business.

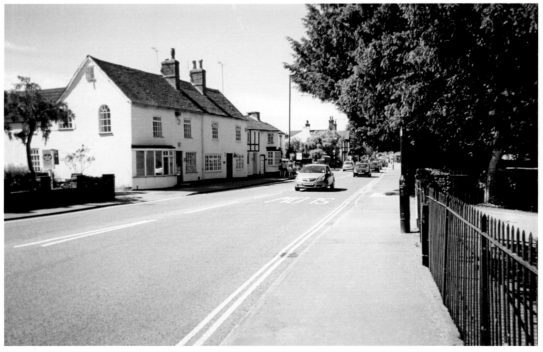

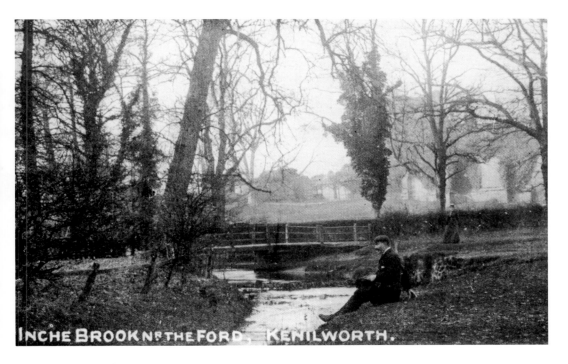

INCHE BROOK Nº THE FORD, KENILWORTH.

Ancient Ford

Almost as famous as the castle is the ancient Ford of Kenilworth. Originally part of the Old Welsh Road the brook that once flowed over it is now piped beneath the road surface. Having said this, the ford is still prone to flooding when excessive rain produces high water.

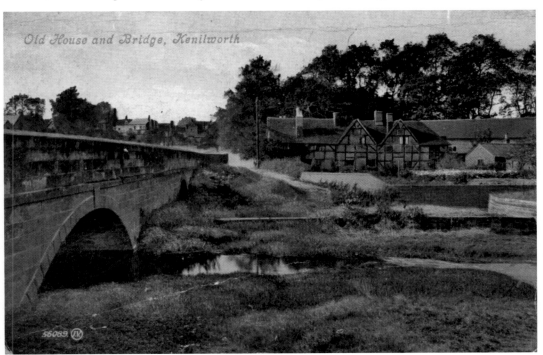

Old House and Bridge, Kenilworth

Queen and Castle

Standing opposite the castle, the Queen and Castle public house and restaurant is very popular with visitors to the area. It has a fountain garden, plenty of car parking spaces and a delightful atmosphere.

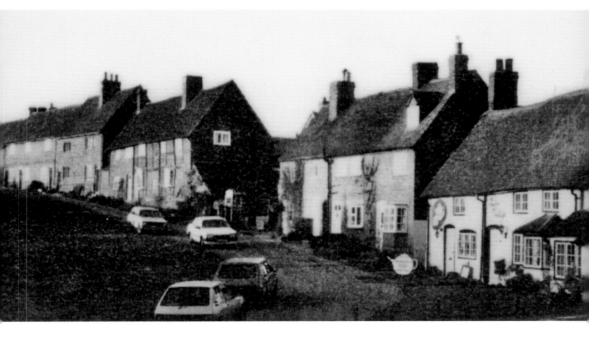

Random Views

The top picture gives us another look at the green and shows the houses further round from the Queen and Castle. The bottom photograph shows the war memorial which stands on the edge of the Abbey Fields and looks down the main road in the town.

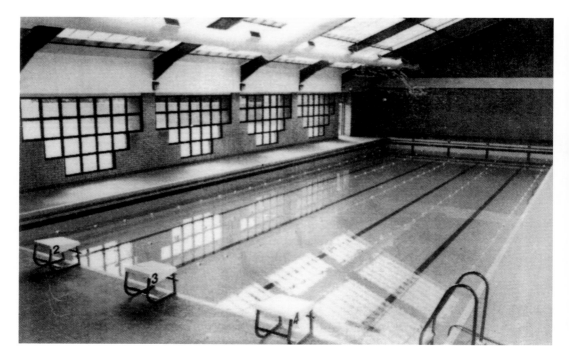

Swimming Baths

Originally opened on 1 June 1896 with water from the brook the open-air swimming baths were improved and extended in 1935, and since this time have been completely rebuilt. I well remember as a teenager travelling by bus to Kenilworth with my boyfriend of the day, to go swimming in the open air pool. Our bathing costumes were rolled up in a towel, along with bathing caps. My cap was a thick white rubber one which was fashionable for the day with a strap that fitted under the chin. To walk over the Abbey Fields past the monument down the hill to the pool still holds a certain magic for me to this day.

St Joseph's Convent

Originally known as St Joseph's Convent for Girls the school was later known as St Joseph's School and then in 2004 it became known as Crackley Hall School. To the older generation I think it will always be referred to as St Joseph's Convent.

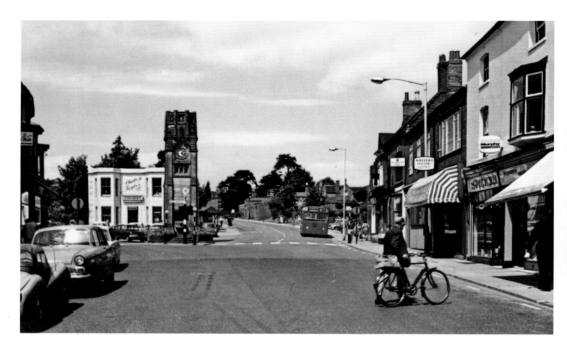

Random Views

The top picture shows the old Midland Red Bus which ran from Leamington and Warwick to Coventry and back. In the days of few cars a trip on the bus was a real treat. I love this photograph as it shows the tower before the hotel was built. Always a serious entrant in the Britain in Bloom competition, Kenilworth in Bloom is very popular in the town. Taken early in the season this corner exhibit shows all the potential of becoming a colourful display.

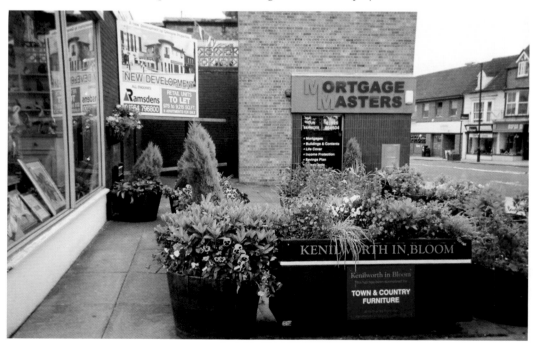

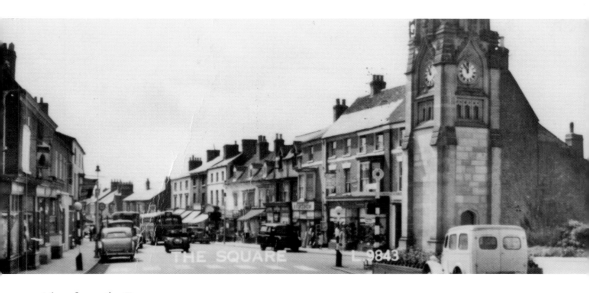

View from the Tower

These photographs show the centre of Kenilworth looking down the main Street towards St John's Church. Usually a very busy thoroughfare I was lucky enough to catch the Warwick Road in a sombre mood in the bottom photograph.

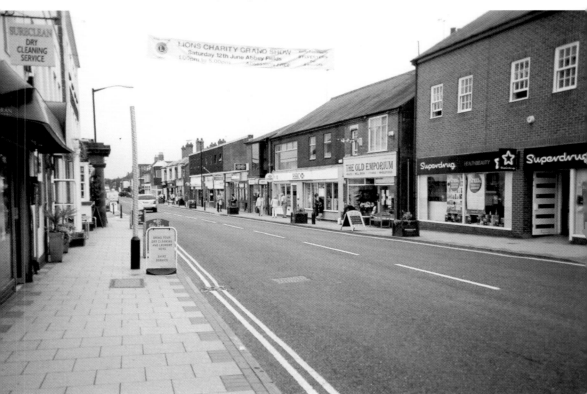

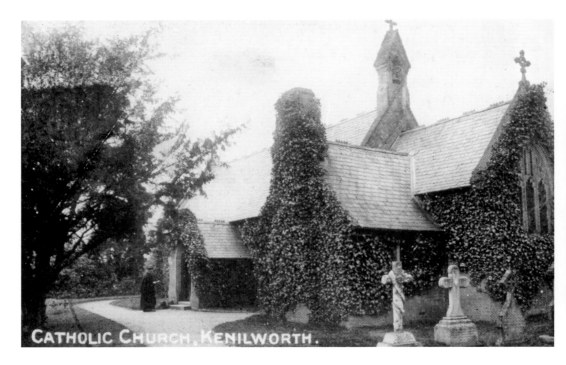

CATHOLIC CHURCH, KENILWORTH.

St Augustine

Designed by Augustus Pugin (1812–1852) is the small Roman Catholic Church of St Augustine. This lovely little church stands in Fieldgate Lane. Augustus Pugin was a young Catholic architect. In contrast we see the newly-built Roman Catholic church which stands in the centre of the town.

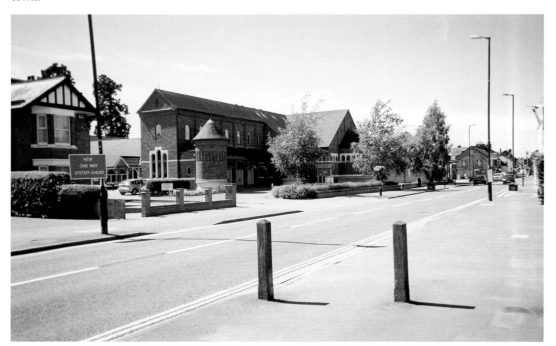

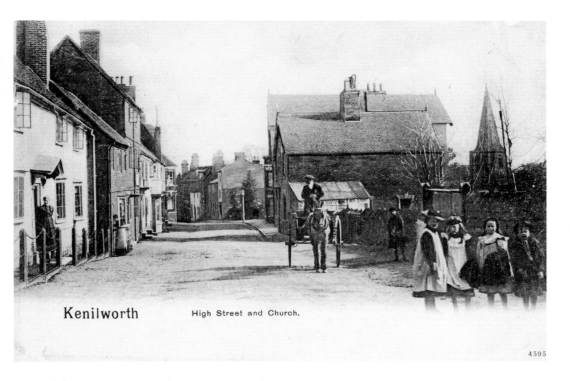

Kenilworth High Street and Church.

4595

High Street

I love the charisma of this delightful old postcard, which gives a totally different insight into a bygone era. I have put the lovely old postcard at the bottom of the page with the High Street as it shows the Queen and Castle end of the street.

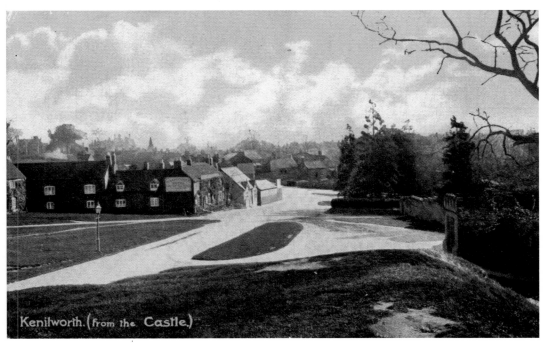

Kenilworth. (from the Castle.)

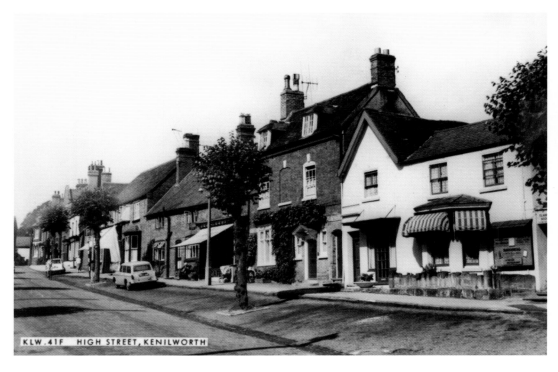

KLW.41F HIGH STREET, KENILWORTH

The Other End

Here we see the other end of the High Street and what a contrast it is. Like all modern towns Kenilworth is plagued by motor cars.

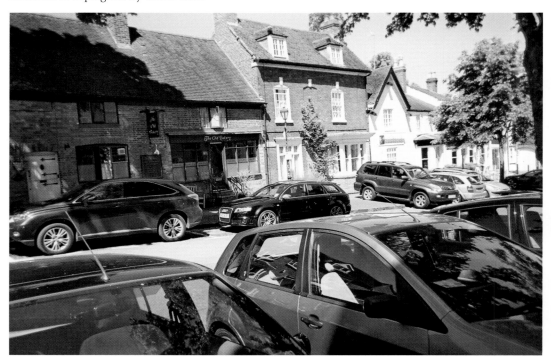

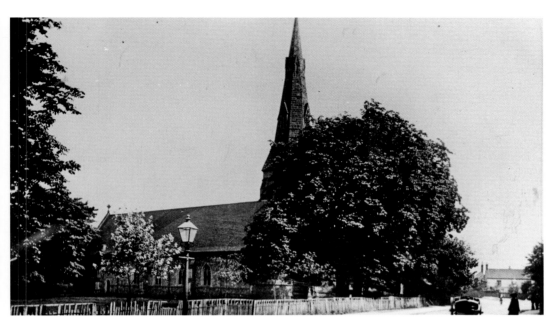

St John's Church

St John's Church was aligned so that the spire was visible from a distance along the roads from Leamington Spa and Warwick.

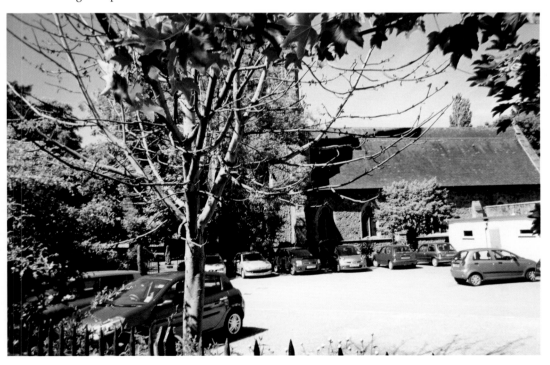

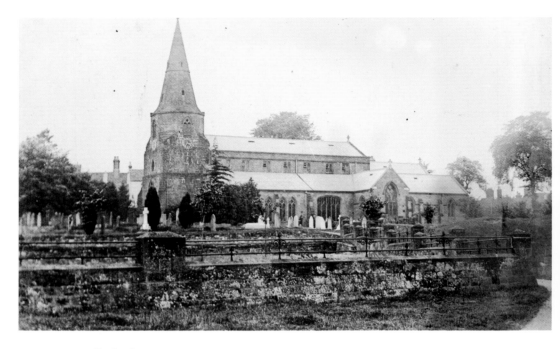

Queen Elizabeth I

The top photograph is another view of St Nicholas Church. The back of the card posted in May 1911 reads 'Just on my way to Evesham. Wind against me as usual'. It never fails to amaze me how far people travelled at this time, I presume on his bike! The card is signed 'Love from Harold'. The bottom photograph shows the Norman doorway at St Nicholas Church. Queen Elizabeth I worshipped at St Nicholas on two occasions while she was a guest at Lord Leicester's Castle.

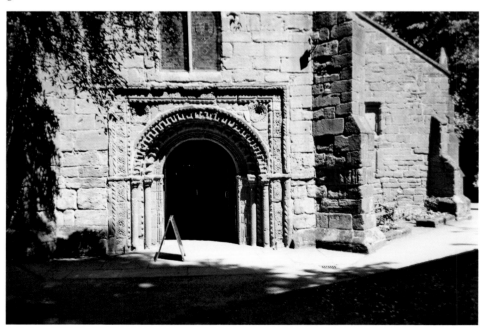

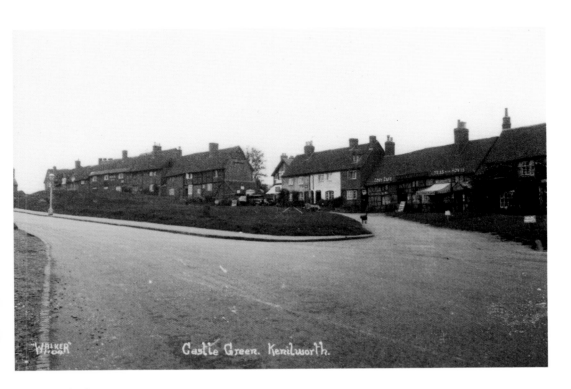

Castle Green

These lovely old cottages on the green would have probably housed the staff who provided essential services for the castle.

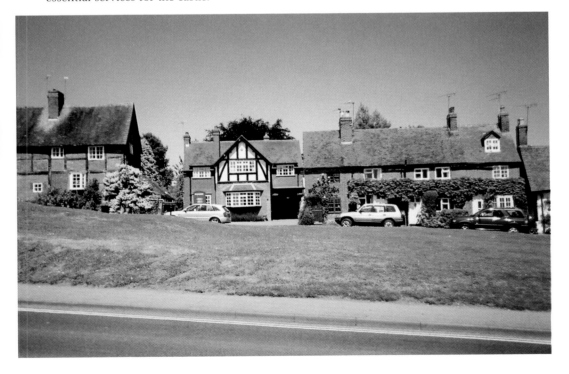

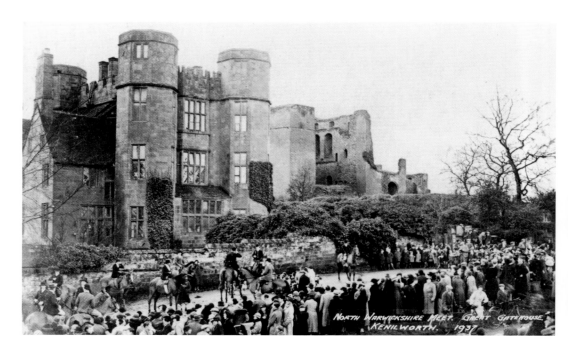

North Kenilworth Meet

Taken in 1937 we take a nostalgic look at the North Kenilworth Meet at the great gatehouse, Kenilworth Castle. The hunt was very popular in this area and my own parents would religiously follow the horses and hounds as they hunted their prey. Obviously I cannot photograph this through time so I have included a lovely picture of the castle from the outer court to accompany it.

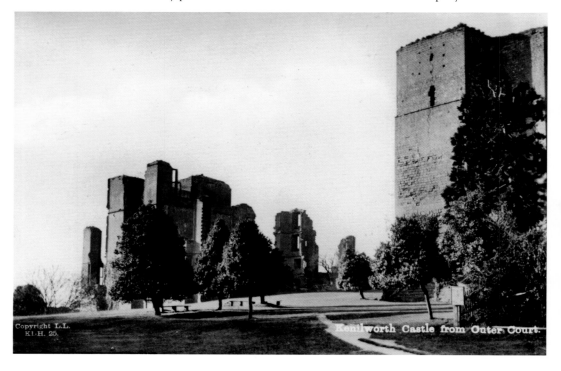

Kenilworth Clock

Presented to Kenilworth by G. W. Turner in 1906, as a memorial to his wife, the clock stands in the centre of the town at the head of the main Warwick Road opposite the shopping area. In 1940 a landmine was dropped nearby and the upper part of the clock was damaged. It was restored to its present form in 1973.

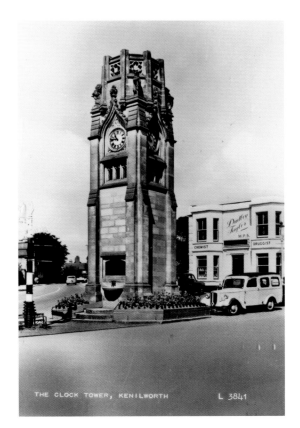

THE CLOCK TOWER, KENILWORTH L 3841

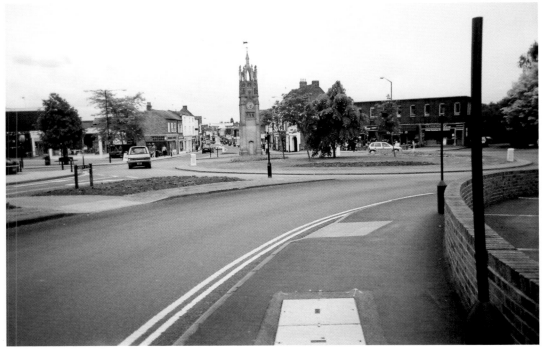

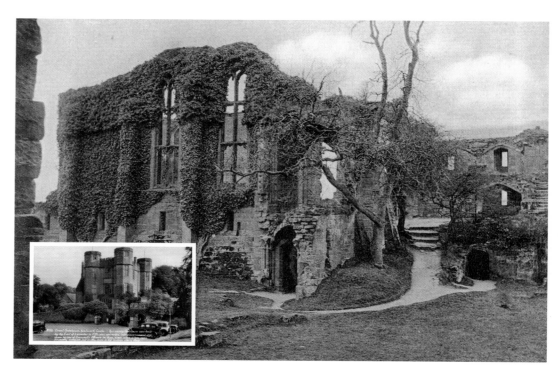

One More Look Back

I have many photographs of Kenilworth Castle, each with a beauty of their own. Here are three more I feel worthy of mention.

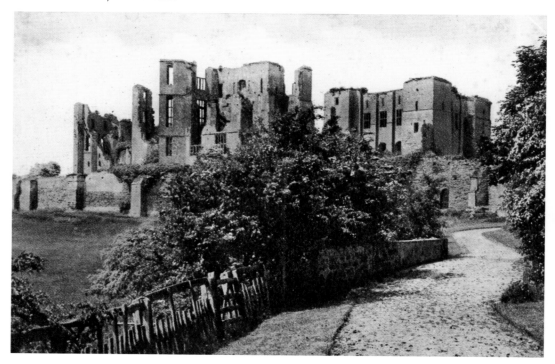

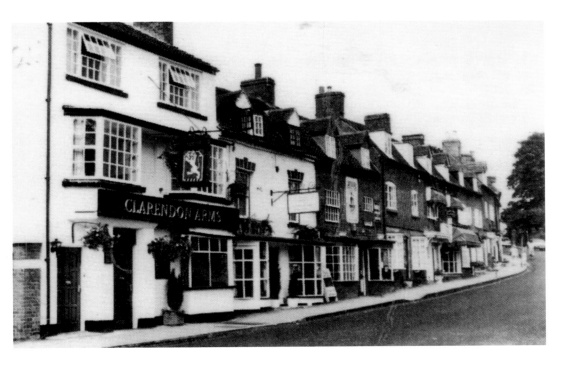

Clarendon Arms

Situated just past Kenilworth Castle is the Clarendon Arms, a delightful watering hole popular with tourists. Castle Hill runs along the top of the Abbey Fields and affords picturesque views of the fields if you care to walk along it.

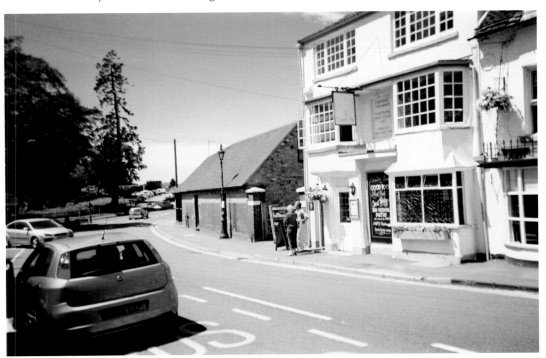

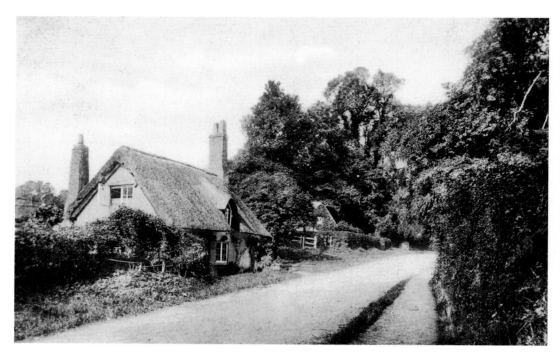

As We Were

I have included these lovely old postcards as they show just how leafy the area was. It certainly endorses the saying 'Leafy Warwickshire'.

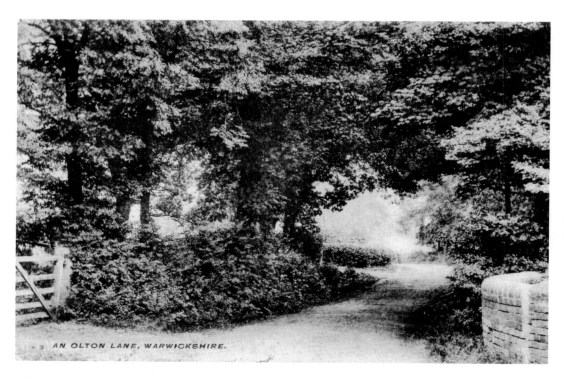

AN OLTON LANE, WARWICKSHIRE.

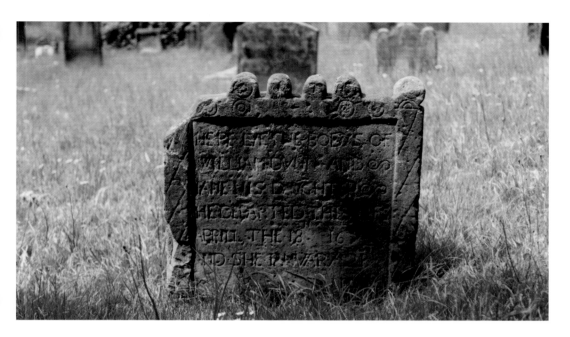

Arrow Sharpening

In St Nicholas churchyard, up the bank towards the houses can be found a most unusual gravestone. On the tombstone is the following epitaph. 'Here lies the body of William Dyer and his Daughter. He departed this life on April 18, 1628 and she January 21, 1706'. I am not sure what the attraction was of this particular gravestone but in the back of it can be found the marks of arrow sharpening, probably made by archers prior to battle.

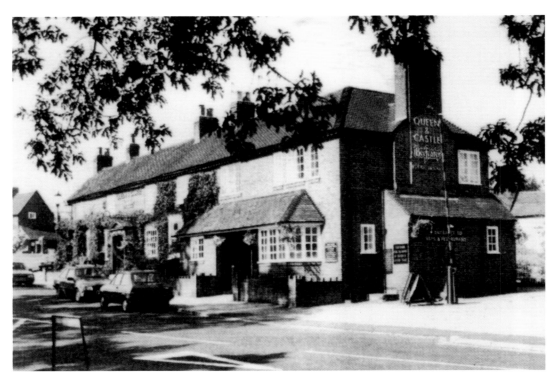

Queen and Castle
This lovely old public house can be found opposite the Kenilworth Castle by the green. It is now a steak house and very popular with locals and tourists alike. A petrol station once flourished to the right of the building.

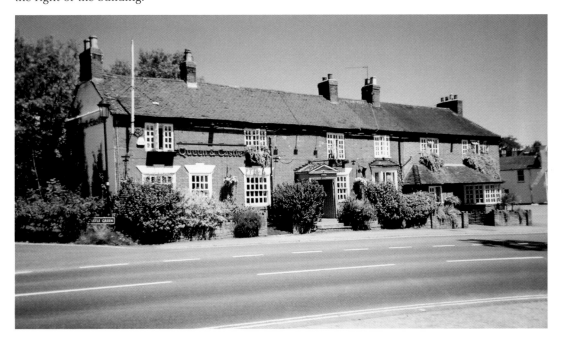

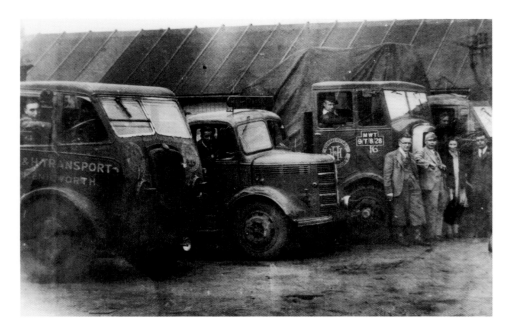

H & H Transport

Kenilworth haulers H & H Transport used 4–7 ton Maudsley Marathons for use with drawbar trailers to transport castings from the Ford Motor Company in Leamington Spa in 1940, to the railway station. Under government contract for the war years the haulers would also deliver the castings to Ford customers. Journeys of this nature were far from easy as masked headlamps were compulsory. With vehicles having specifications primitive to today's standards and the total absence of signposts, the journey would have been a nightmare. The man in the lorry on the left was Mr Harry Cox. The bottom photograph is of Starbucks, which is on the ground floor of the Holiday Inn.

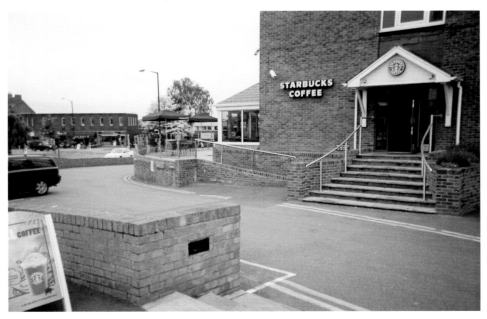

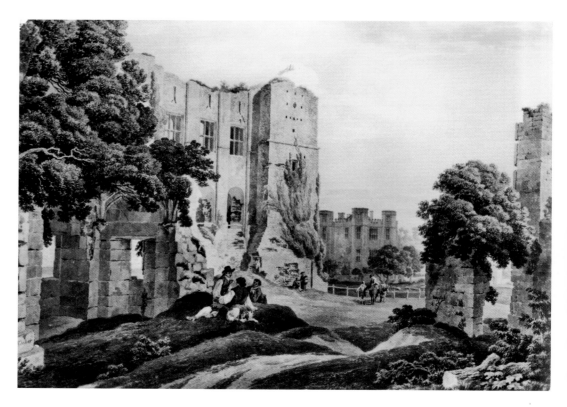

Caesar's Tower

Caeser's Tower in days of old. I love something different and this delightful picture by Michael Angelo Rooker (1743–1801) of the tower puts a more personal feel to the castle for me. The bottom picture continues with the charisma of the period and I think the two go together beautifully. It's almost as if time stood still.

"In the Days of Old."

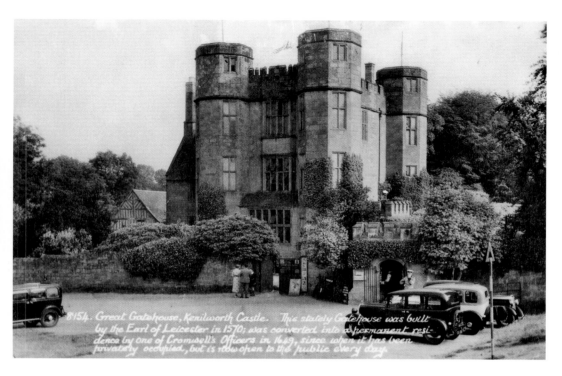

8154. Great Gatehouse, Kenilworth Castle. This stately Gatehouse was built by the Earl of Leicester in 1570; was converted into a permanent resi-dence by one of Cromwell's Officers in 1649, since when it has been privately occupied, but is now open to the public every day.

Two of a Kind
These lovely pictures compliment each other. The top postcard shows Kenilworth Castle and the bottom picture shows how it is today.

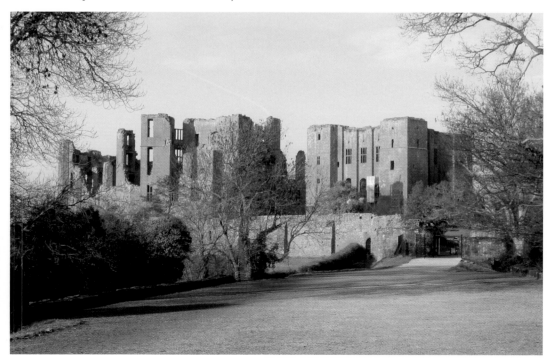

The Town's Historic Cinema

The top picture is of the old Picture House which stood opposite the railway station and although I do not have an old picture of the cinema I think it is worthy of mention as it is part of the history of the town. Growing up at a time when the motorcar was a luxury few could afford, people from around the area came by train to watch the films. These films would be advertised in the local newspaper every week and it was a great place to go on your first date as clubs and the like were not in vogue then. Enjoying a cigarette on the steps of the old cinema is James McFerran an employee of the business that now occupies the building.The bottom photograph shows the very old part on the right of St John's school room.

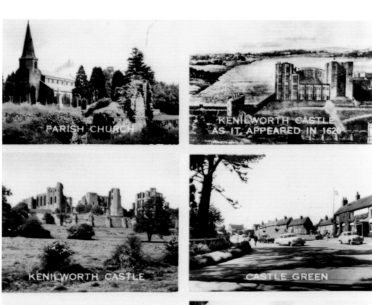

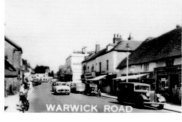

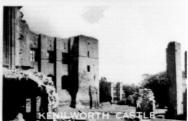

Old and Modern
Two contrasting views of Kenilworth. The bottom photograph shows the main Warwick Road which runs through the town.

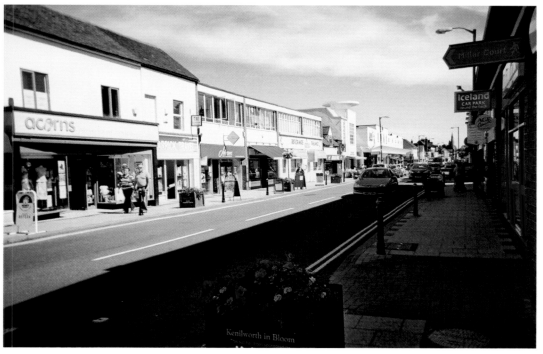

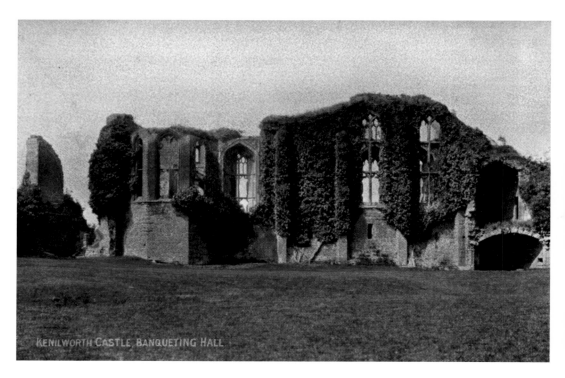

KENILWORTH CASTLE BANQUETING HALL

The Banqueting Hall

Situated on the western edge of the town, Kenilworth Castle, with its reddish brown sandstone makes an impressive sight in any weather. Taken through time the top postcard, in colour, shows how reproductions have improved over the years.

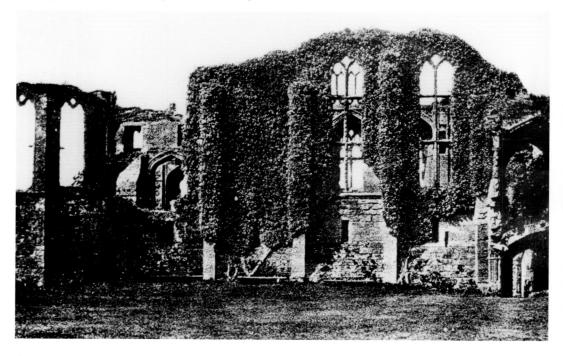

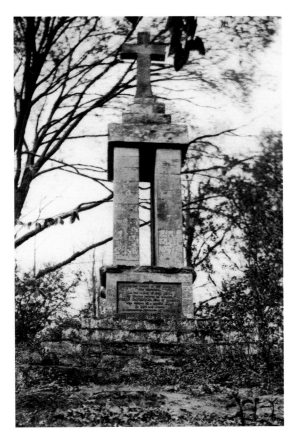

Around and About

Here we see the Piers Gaveston Monument which can be found on the edge of Leek Wootton. Gaveston lost favour with Queen Isabella and met his demise! The bottom postcard shows a close up of the waterfall at Guy's Cliff. I have put these two old pictures together as they both stand in the same corner of Warwickshire.

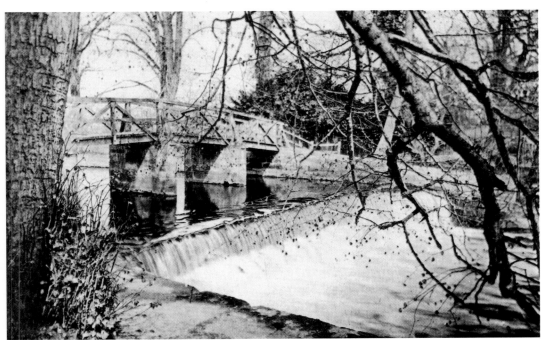

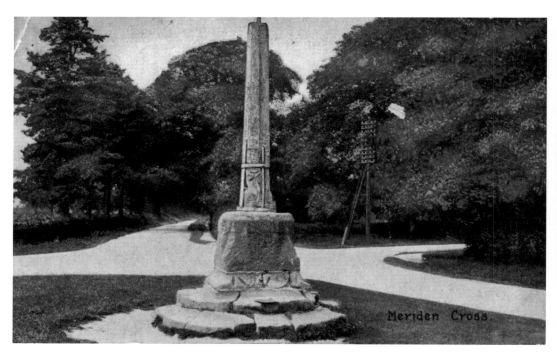

Meriden Cross

Reputed to be the centre of England, I have included this photograph of the Meriden Cross. It is interesting to observe the introduction of red sky on the bottom postcard.

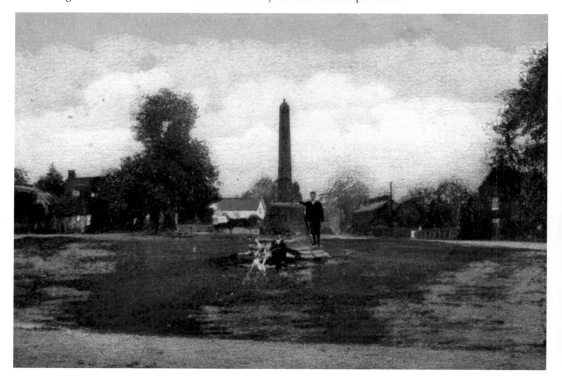

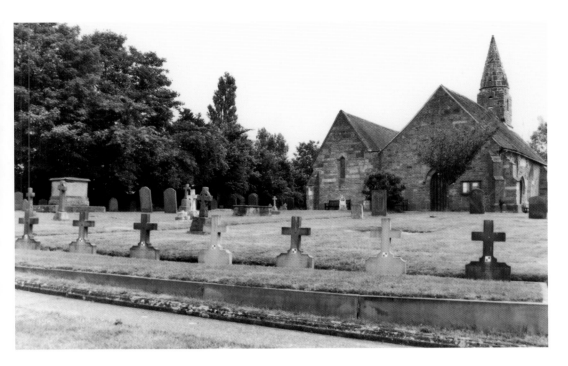

St John Baptist

Built in the thirteenth century the church of St John the Baptist stands but a stone's throw away from the River Sowe at Baginton. With its quaint octagonal bell turret, supported on the south side by a massive buttress on the outside wall, the interior can only be described as an ecclesiastical museum. The Bromleys from the ill-fated Baginton Hall lie in their own mausoleum here. In the churchyard are nine graves, the resting place of Polish airmen who died as the result of an air raid in the early 1940s.

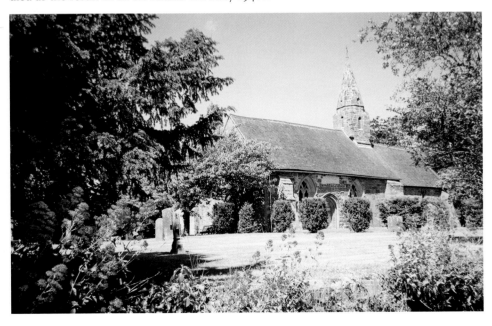

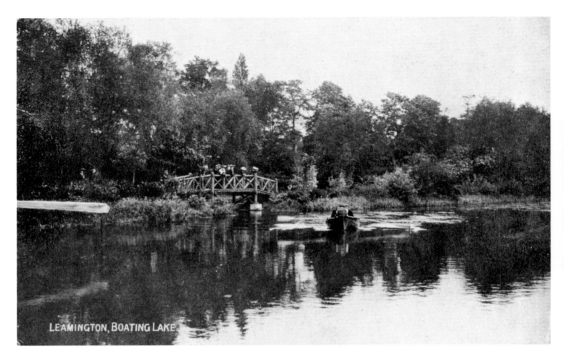

Leamington Spa

Two contrasting views from Royal Leamington Spa. The top picture shows the boating lake, as boating on the river has always been a popular pursuit in Leamington and the bottom picture shows children playing in York Walk.

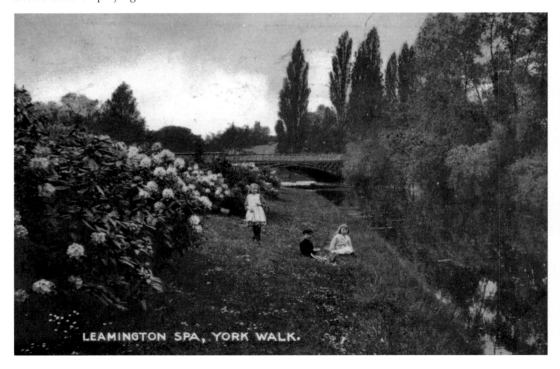

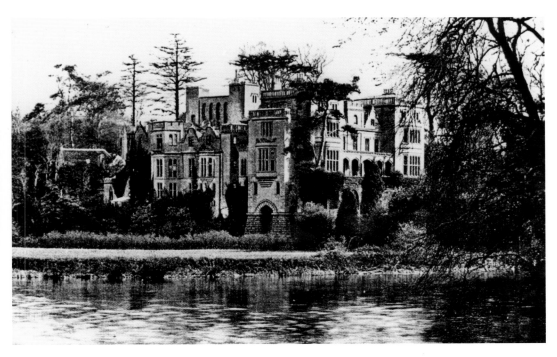

Guy's Cliff

Two lovely contrasting postcards of Guy's Cliff – I have placed an old coloured print at the bottom of the page with the top postcard to show how coloured photography has travelled through time.

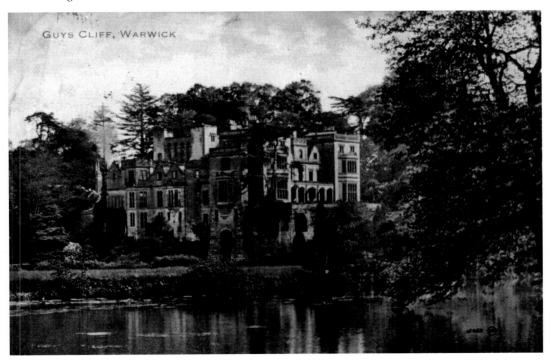

GUYS CLIFF, WARWICK

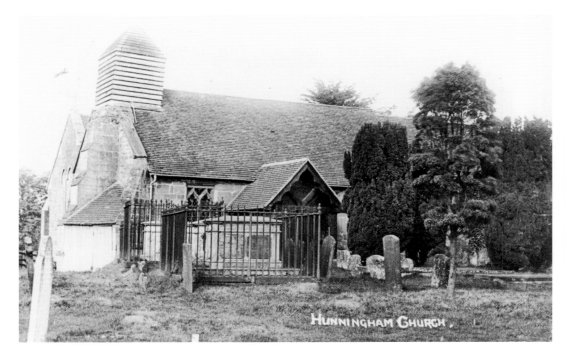

St Margaret's Church

Derived from ancient times and meaning 'Huna's People', Hunningham lies north east of Leamington Spa. St Margaret's Church has changed a great deal since the top photograph was taken and now has a driveway with sunken lights to the doorway of the church, which enables worshippers to find their way to the church during winter time. The village boasts a local nature reserve and the Red Lion public house which is prone to flooding.

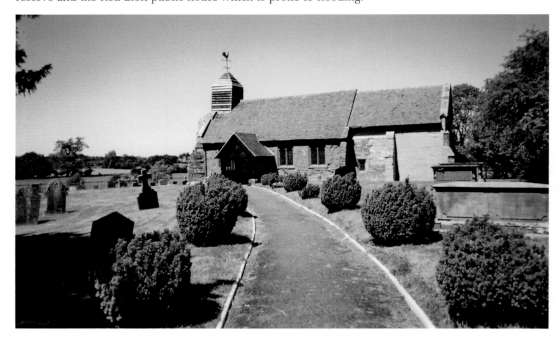

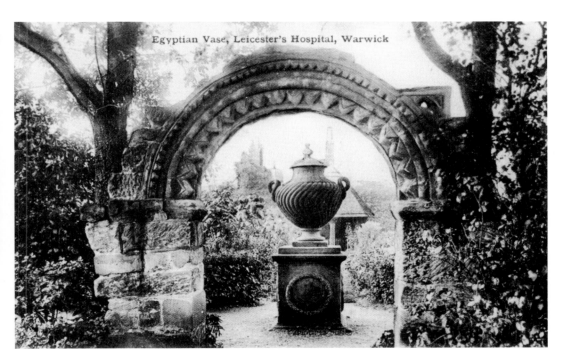

Egyptian Vase, Leicester's Hospital, Warwick

Lord Leicester's Hospital

Here we have two lovely views of the old historic house of Lord Leicester in Warwick. With its connection to our senior members of society I felt it only fitting to include with the picture of the Egyptian vase a pensioner proudly showing off his medals.

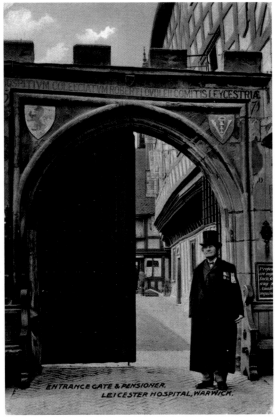

ENTRANCE GATE & PENSIONER,
LEICESTER HOSPITAL, WARWICK.

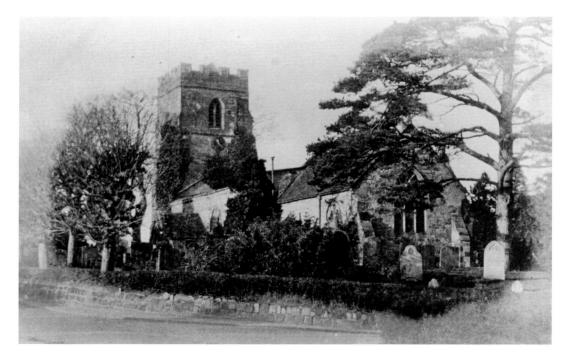

Offchurch

The church is dedicated to St Gregory (who sent St Augustine on his mission of conversion to England). It has the blocked-up north door, the 'Devil's door', so often found in Norman churches and a carved slab of stone said to be the lid from Offa's coffin. The peaceful Offa, King of Mercians, from whom the village takes its name, is said to have had a palace here in the eighth century. Bullet scorings on the tower commemorate the times when the Civil War disrupted the quiet of so many sleepy, out of the way villages.

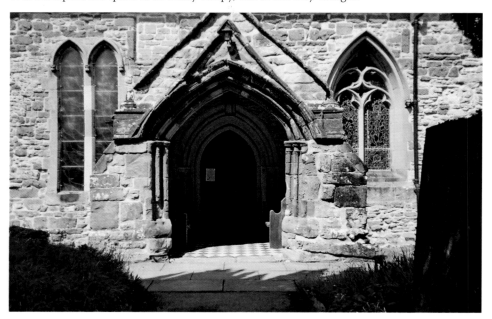

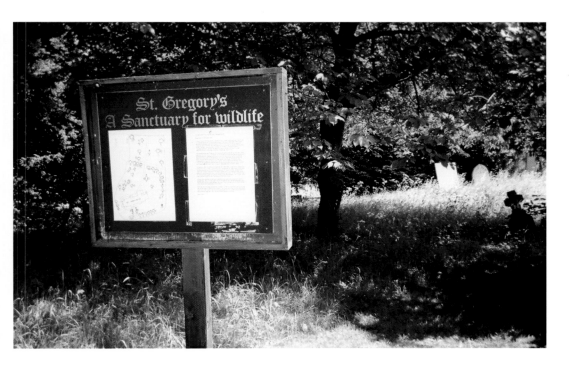

St Gregory's Wildlife Sanctuary
I had a lovely surprise when I came upon this sanctuary for wildlife in the churchyard at St Gregory's. I came upon it quite unexpectedly, and thought it was a perfect use of such a peaceful area.

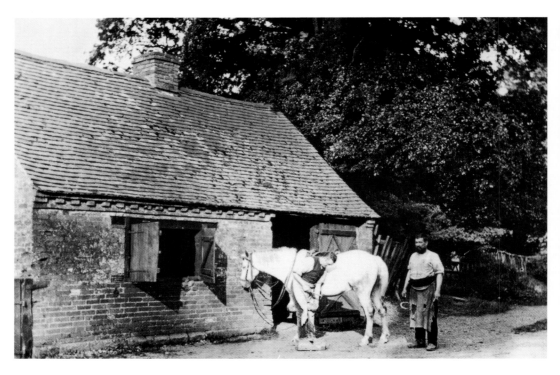

The Smithy

Taken from a photograph in 1860 here is a delightful look back in time to the life of a blacksmith at the Smithy in Coat of Arms Bridge Road, Coventry. While we are in Coventry let's take another step back in time and enjoy the Grove.

The Grove, Coventry.

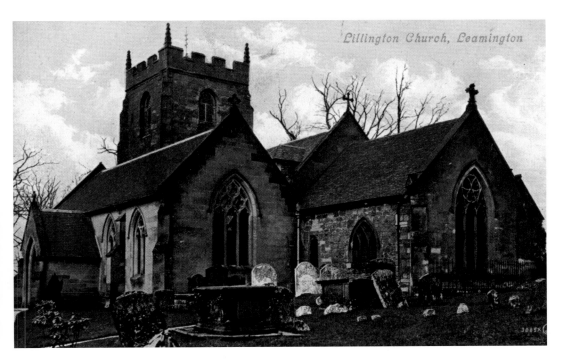

Churches

The top postcard is Lillington Church and the bottom postcard shows the high altar at All Saints Church in Royal Leamington Spa. I well remember going to see a flower show in All Saints Church a few years ago and it was a pleasure to visit.

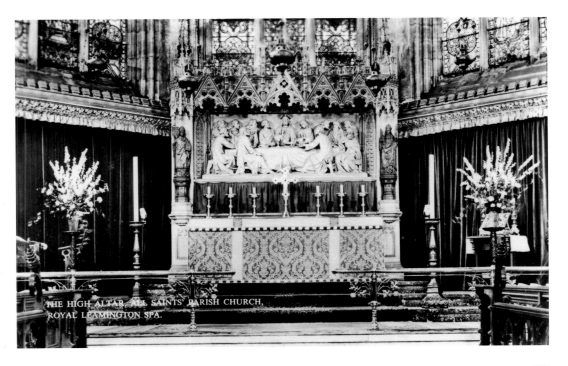

THE HIGH ALTAR, ALL SAINTS' PARISH CHURCH, ROYAL LEAMINGTON SPA.

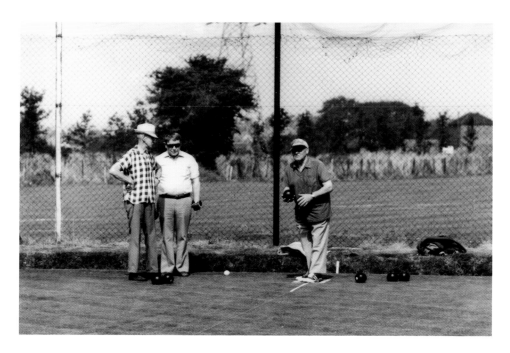

Blind Bowlers

The Blind Bowlers seen bowling at Leamington Bowling Green and the sports ground of the Imperial Foundry. In the bottom photograph we see Bill Wilson measuring the shot. I watched them bowling many times and marvelled at how talented the players were getting near to the white ball. For players whose sight was not so good a handkerchief would come into play and Bill or his associates would hold up the handkerchief near to the white ball, enabling the bowlers to get a better view of where they are aiming. Sadly Bill passed away some years ago but he has left everyone who knew him with some lovely memories.

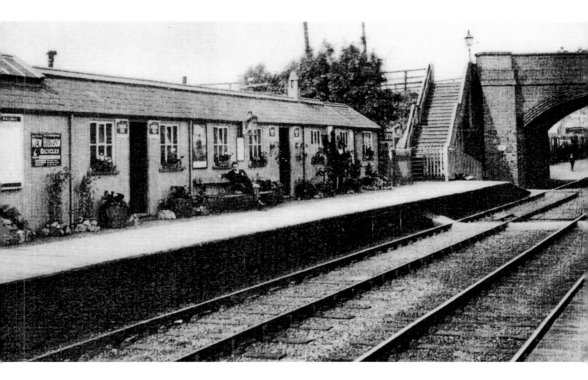

Random Glimpses

I have included this lovely old photograph of the valley in Radford Semele. Unfortunately these old houses are no more. Above you can see an old print of Napton and Stockton Railway line, the line was opened in 1895. Mr E. B. Law is standing next to the station clock.

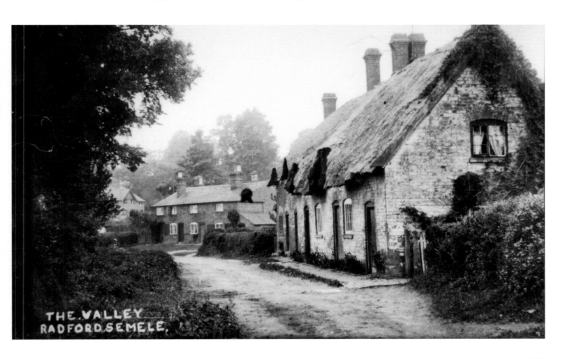

The Town and Country Show

These lovely old cars were photographed at the Town and Country Show which was held each August Bank Holiday on the National Agricultural Centre ground at Stoneleigh. Sadly the show is no longer held, supposedly through lack of support.

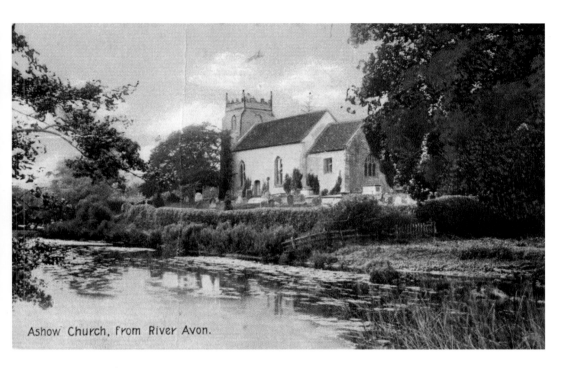

Ashow Church, from River Avon.

Ashow Church

I was not quite sure what I might find when I made my way down a long winding path to the churchyard of Ashow Church. So it was a pleasant surprise when I found Avril Newey here enjoying a picnic. She told me that she had been brought down to the river that skirts Ashow Church as a child by her mother, so that they could paddle in the water. It was during the Second World War, and the seaside could only be seen in picture books. It was a pleasure to join her for a few moments down memory lane.

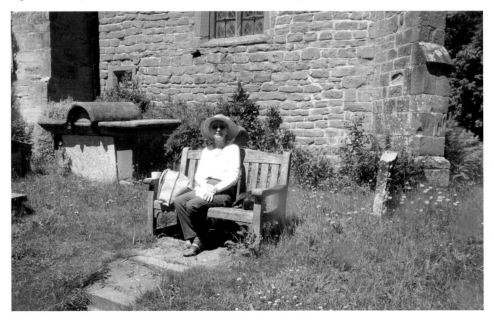

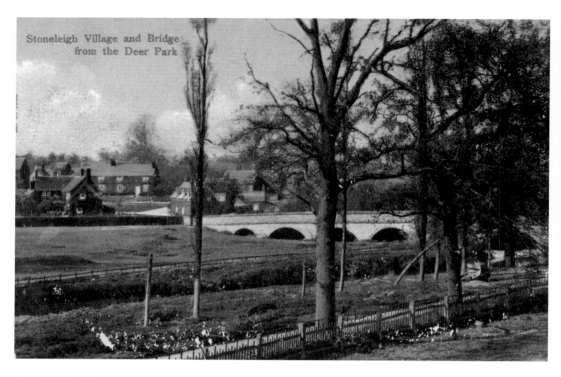

Stoneleigh Village and Bridge from the Deer Park

Stoneleigh Village

Just a stone's throw away from Kenilworth lies Stoneleigh and if you cross the bridge and turn left the road will take you in the direction of Kenilworth. The bottom photograph just shows how scenes change through time.

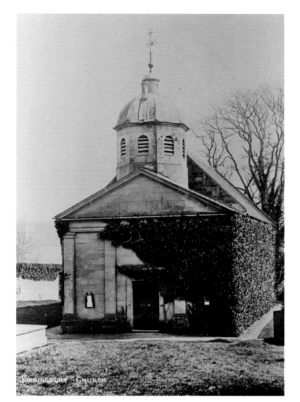

St Leonard's Church

This has to be one of the most unusual churches, which is partly Victorian and partly Georgian in design and stands in the village of Birdingbury. Although the village appears on the Christopher Saxton map of 1637, the houses are mostly twentieth century. The hall dates back to the early seventeenth century and was rebuilt in the Jacobean style in 1859, after being damaged in a fire. The railway which was built in 1851 north of the village, on the Rugby to Leamington line, is now a cycleway.

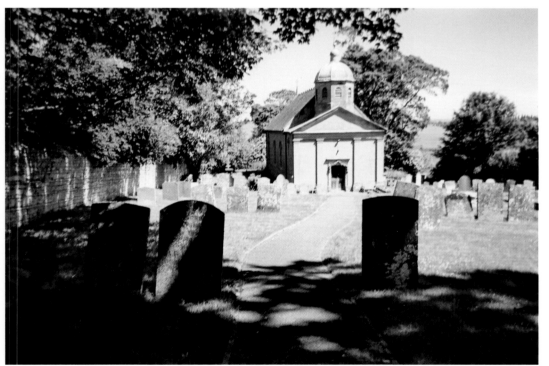

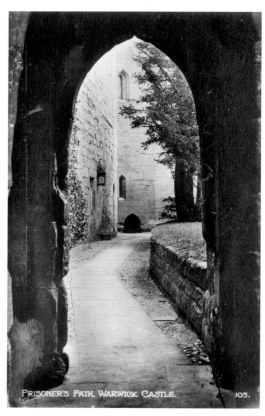

PRISONER'S PATH, WARWICK CASTLE. 105.

A Peep into the Past
The top postcard shows the Prisoner's Path at Warwick Castle, and the bottom postcard shows the tumble-down stile at Charlecote.

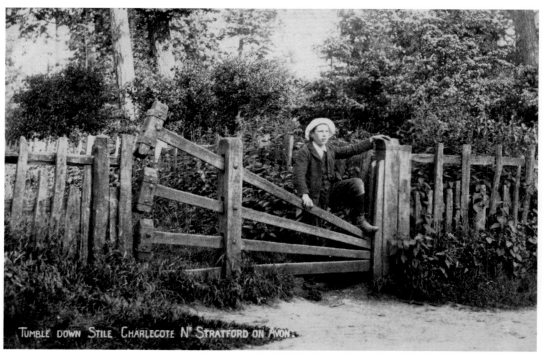

TUMBLE DOWN STILE CHARLECOTE Nr STRATFORD ON AVON.

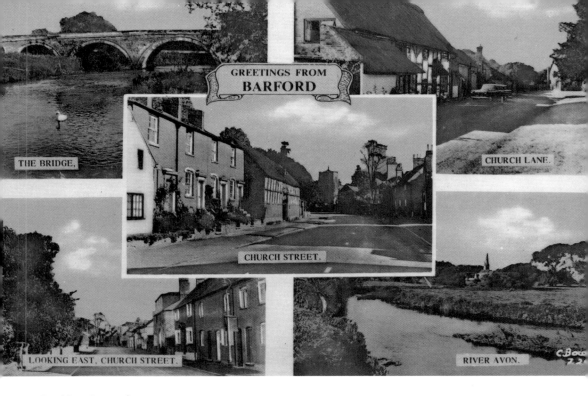

GREETINGS FROM
BARFORD

THE BRIDGE,

CHURCH LANE.

CHURCH STREET.

LOOKING EAST, CHURCH STREET.

RIVER AVON.

Looking Around

I continue our peep into the past with two old postcards, one shows Barford and the other Royal Leamington Spa.

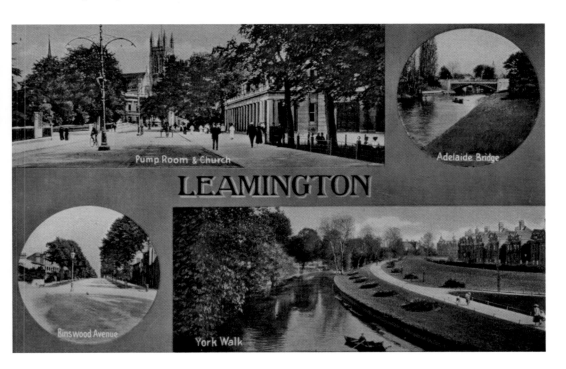

Pump Room & Church

Adelaide Bridge

LEAMINGTON

Binswood Avenue

York Walk

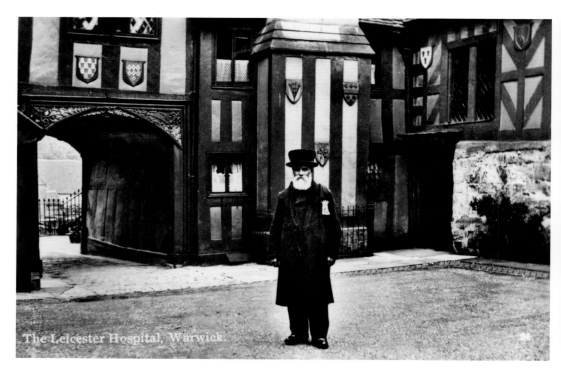

The Leicester Hospital, Warwick

Leicester Hospital

Two more lovely old postcards of Lord Leicester's Hospital and once again I have used an old coloured postcard to reflect time.

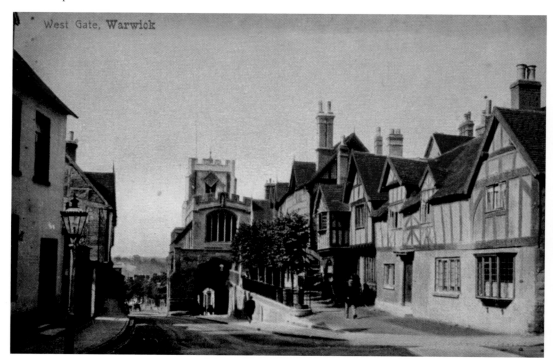

West Gate, Warwick

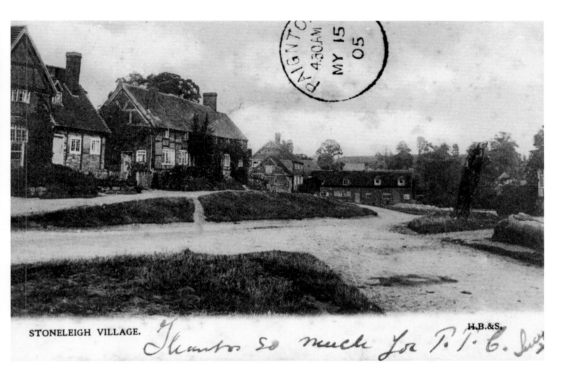

STONELEIGH VILLAGE. *Thanks so much for P.T.C. ...* H.B.&S.

Stoneleigh Village

Stoneleigh village and here we see an insight into changing times. There are no cars in the top picture!

The Forge

Stoneleigh has one of the few remaining forges in the area and it was quite a common sight to see horses waiting for a new set of shoes.

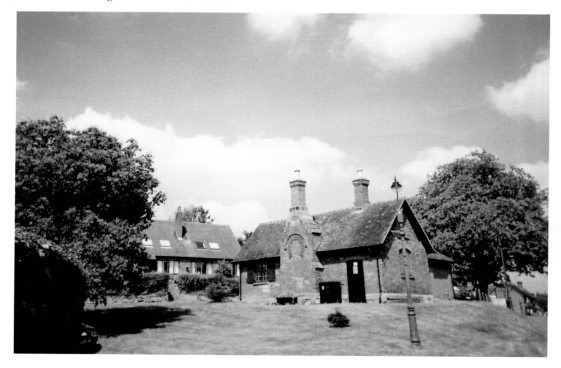

Hampton on the Hill Football Team

With all old photographs trying to put a name to all of the faces is very difficult but I have managed to find the names of some of the players on this old print of Hampton on the Hill football team. Back row far left Jabez (aka Jimmy) Gulliver, fourth from left George Vincent. Far right a man called Vincent who was father of three of the players George, Ron and Bert. Middle row second from left Ron Vincent and front row second from left Tom Collett, third from left George Bourton, fourth from left Bert Vincent. There were also players called E. Tracy and T. Field.

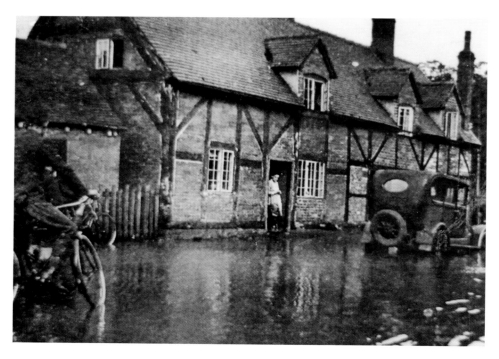

Ashow

Unfortunately the village of Ashow is prone to flooding as the river runs close to the village. This picture taken in the 1930s shows the results of a swollen river and below after the storm.

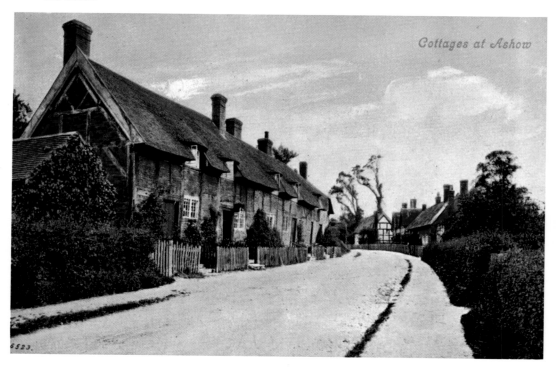

Cottages at Ashow

6523.

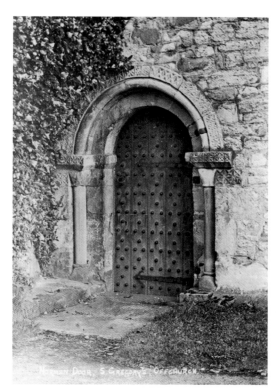

The Norman Door

I could not visit St Gregory's Church at Offchurch without including a picture of the famous Norman door. The top picture was taken in 1903 and the bottom photograph in 2010. They obviously made doors to last in those days.

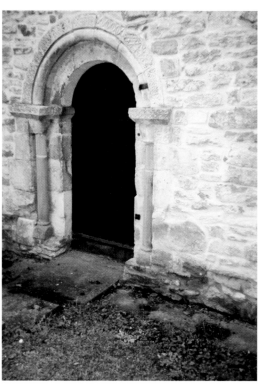

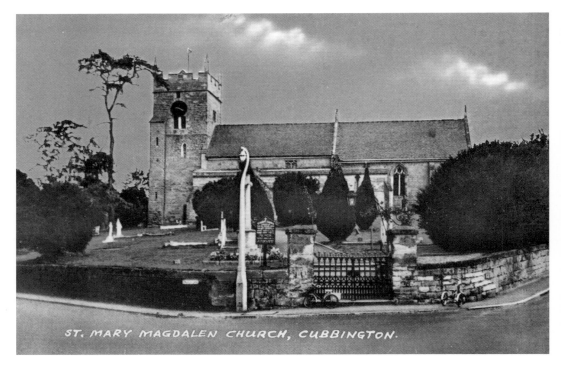

ST. MARY MAGDALEN CHURCH, CUBBINGTON.

Parish Church Cubbington
The parish church of Cubbington is dedicated to the 'Nativity of our Lady'. The church consists of a nave, south side and a small chancel, with the tower being added about 1857. When you enter the church you are struck by the curious appearance of the walls. It is almost as though they have departed from the perpendicular. The bottom picture shows the bell ringer about to burst into action.

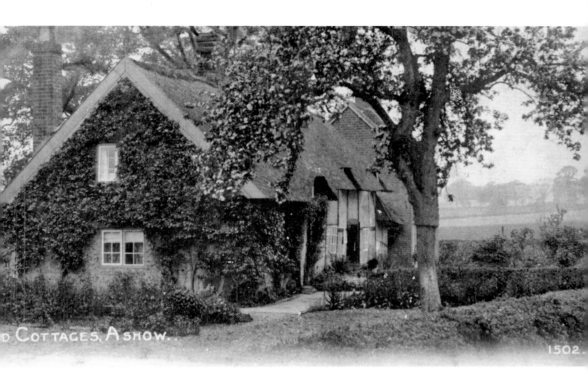

Ashow Cottages
I love postcards showing ancient dwellings and here is a row of old cottages in Ashow. The photograph below is of Ashow Village Club decked out for the 2010 World Cup.

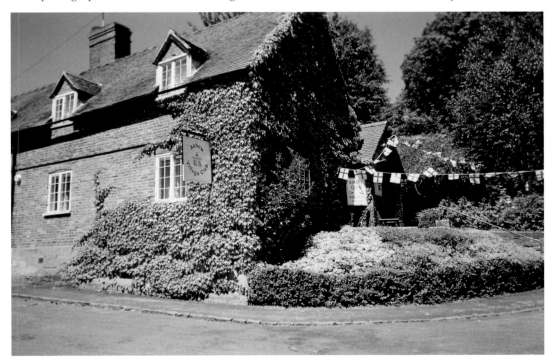

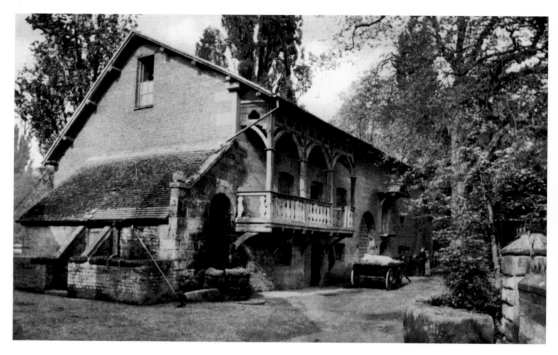

Guy's Cliff

Here we see the Guy's Cliff Mill and my father, a farmer's son, used to talk of the days when as a lad he would accompany his father to the mill to get the corn ground. The bottom photograph shows Scotch Avenue at Guy's Cliff House in Warwick.

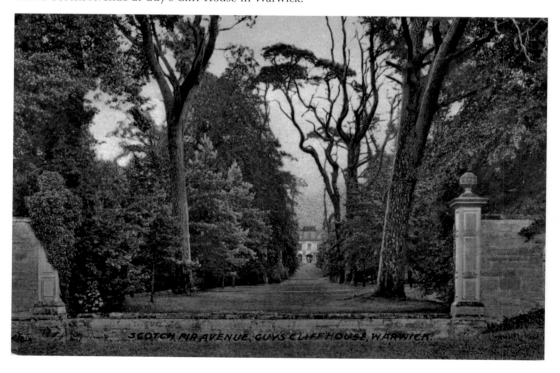

SCOTCH FIR AVENUE, GUYS CLIFF HOUSE, WARWICK.

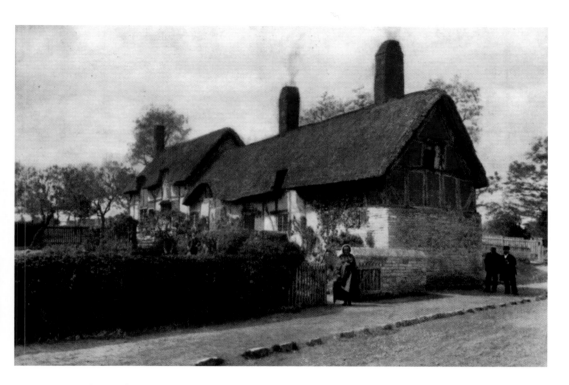

Ann Hathaway's Cottage

I love these two old postcards of Ann Hathaway's cottage and its interior. Coloured postcards were certainly moving through time here.

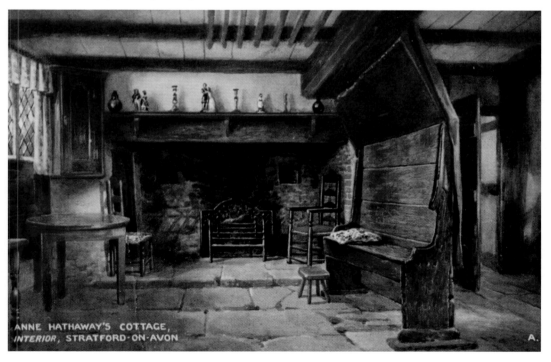

ANNE HATHAWAY'S COTTAGE, INTERIOR, STRATFORD-ON-AVON

A.

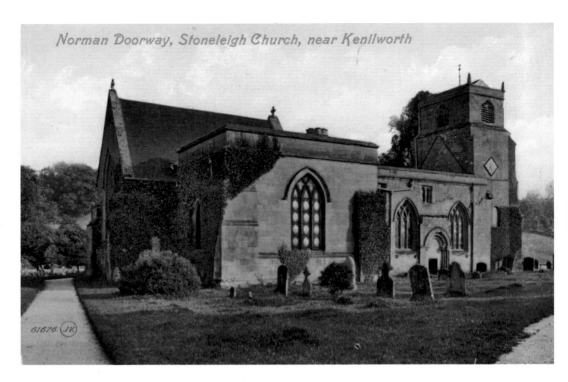

Norman Doorway, Stoneleigh Church, near Kenilworth

61676. (JV.)

Stoneleigh Church

I have included four photographs of Stoneleigh Church as it lends itself beautifully into the leisure life of the community. A bridal path weaves its way through the churchyard and in the bottom photograph, taking a rest along the way are Mr and Mrs Jones.

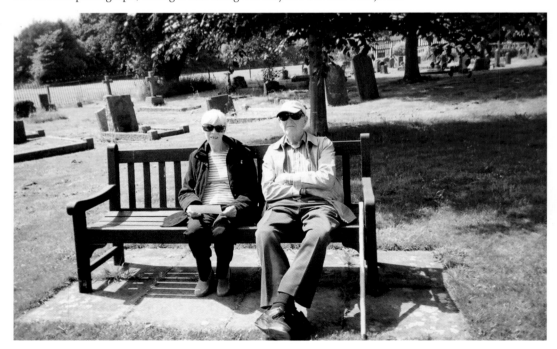

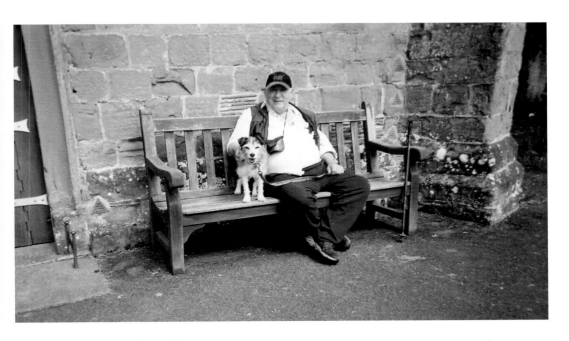

Stoneleigh Church – Take Two

On this page we see Mr Stephens and his lovely dog taking a rest in the churchyard. Mr Stephens assured me his name was Stephens spelt the Welsh way. I couldn't resist introducing him the Mr and Mrs Jones! In the bottom picture Mike the gardener beavers away keeping the churchyard tidy. The grounds are a credit to him. It was a pleasure to visit Stoneleigh Church and far from being neglected it was alive, not only with the birds singing, but with people who had found the time to enjoy it.

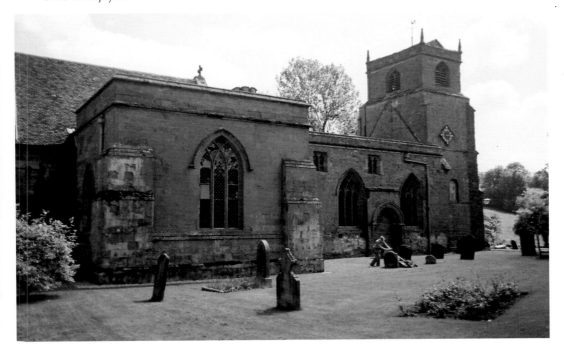

Leek Wootton

Here we see two contrasting views of Leek Wootton which lies only a very short distance from Kenilworth. Leek Wootton was well known for the Police Headquarters that were based there.